The Medieval Flower Book

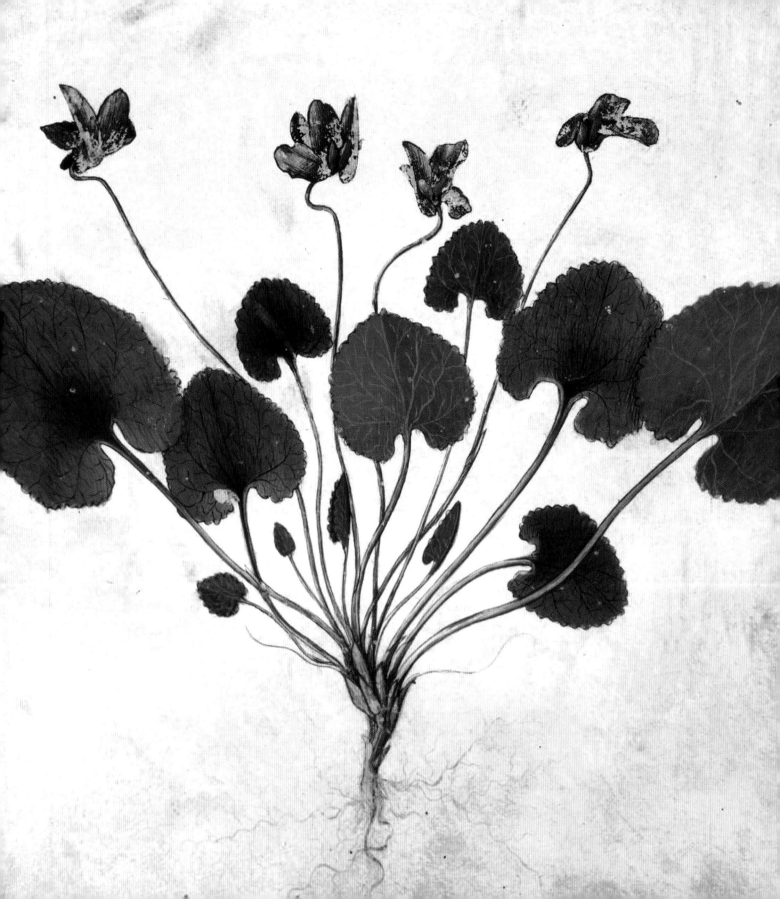

The Medieval Flower Book

Celia Fisher

THE BRITISH LIBRARY

First published 2007
by The British Library
96 Euston Road
London NW1 2DB

British Library
Cataloguing-in-Publication
Data
A Catalogue record for this
book is available from
The British Library

ISBN 978 0 7123 4945 1

Designed and typeset by
Bobby & Co, London
Printed and bound by
Printer Trento s.r.l.
Italy

RIGHT *Plant drawings by the
London surgeon John Arderne.*
Treatise of John Arderne,
English, mid-14th century:
Add. MS 29301, f.3v.

TITLE PAGE *Violets*
(Viola canina).
Carrara Herbal, Italian,
c.1400: Egerton ms 2020, f.94r.

FRONT JACKET
Sweet peas
(Lathyrus odoratus).
*Bourdichon Hours, French, early
16th century: Add. MS 18855,
f.12.*

BACK JACKET
Apples (Malus domestica).
*Bourdichon Hours, French, early
16th century: Add. MS 35214,
f.67.*

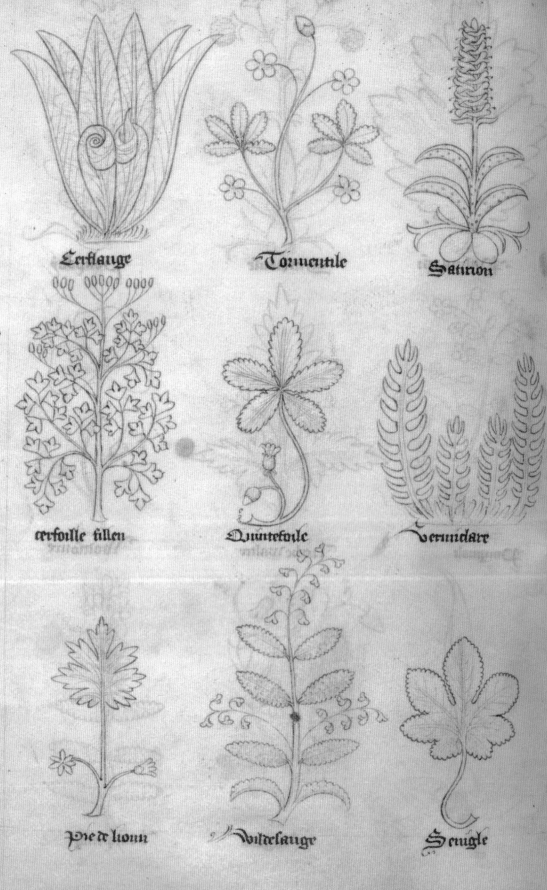

Author's Note

A few words of explanation, tinged with apology, are due to those who explore this book for the flowers, medicines, traditions or symbolism they hope to find. As much as possible has been included, but more has been left out, and this small volume can serve only as an introduction to the great variety of medieval plants and their even more various uses, from glues to aphrodisiacs and from holy or heraldic emblems to gripe water. The flowers have been ordered according to their English, rather than their Latin, names (so *calendula* will be found under marigold and *aquilegia* under columbine), although some flowers, like acanthus and hellebore, are the same in English and in Latin. Occasionally a new taxonomic name known only to botanists has been ignored in favour of the old name. Time and again, the entry for one chosen plant in this book expanded into a related group of several plants and the alphabetical framework of the book became a little compromised, thus cowslip is included under primrose, and raspberries find a place alongside blackberries. There is always the index for serious searching, but above all this book is intended to delight the eye and tease the fancy while it imparts its knowledge.

Contents

Introduction
Plants in Context

NOW THAT THE SURVIVAL of the natural world is increasingly an issue, and is recognised as a delicate balance where ignorance is dangerous, medieval attempts at scientific understanding, including health and the properties of plants, deserve more appreciation. In view of the courage and curiosity needed to match a cure to a disease, it is small wonder that so much reliance was then placed on imparting traditional knowledge. Indeed, many of the plants regarded with superstitious awe in the past are now identified as anti-inflammatory, antiseptic, antiviral or hallucinogenic; while research into placebos suggests there was a psychological justification for associating remedies with supernatural powers.

Classical sources of botanical knowledge were revered in both Christian and Islamic medicine. Some still survive, including the work of Theophrastus, a pupil of Aristotle, whose *Enquiry into Plants* dates from the 4th century BC, and the Elder Pliny, whose *Encyclopedia of Natural History* was written in the 1st century AD. But the most important classical text, which provided the basis of most medieval herbals, was Dioscorides' *De Materia Medica*, also written in the 1st century AD. It was firmly based on his experience as a doctor in the Roman army and his introduction stressed the importance of 'knowing most herbs with mine own eyes…often times and in divers places….and diligently inquiring of each sort'. It helped that Latin remained the lingua franca of medieval Europe, but Dioscorides was also translated into every language from Arabic to Anglo-Saxon, being amended, annotated and sometimes confused – for instance, by the addition of medical recipes from a 4th-century source known as Apuleius Platonicus, who was subsequently credited with joint authorship.

Sometimes in herbals plants were grouped and classified by criteria still in use. Scented herbs like sage, lavender and mint had an obvious family relationship, as did peas, beans, broom and lupins, which produced their seeds in pods. Everyone knew about orchids, which were a popular example of the doctrine of signatures whereby a plant bore, like a medicine label, some dominant characteristic indicating its powers. The huge *Compositae* family was subdivided into those, like daisies, whose flowers seemed to reflect the sun and moon; or those with milky latex, like lettuce, dandelion and some thistles; while those with aromatic leaves, like artemisia and feverfew, ended up among the equally pungent umbellifers, such as dill and fennel. When plants were grouped by scent, spring bulbs and wallflowers tended to be called violets, and any plant exuding a hint of cloves, like pinks and stocks, was a gillyflower. Sometimes growth habit, such as the climbing propensities of hops and bindweed, placed plants side by side on a page. Other times, with plants like sorrels, it was their flavour that united them.

Problems of identification arose after centuries of copying reduced many plant illustrations to an unrecognisable mass of thick leaves and blobby flowers, except where a plant had very strong individual characteristics, like the vicious stems of brambles or the decorative curves of cyclamen. Antidotes to venomous bites were enlivened by pictures of writhing serpents, and the mandrake images were executed with gruesome relish. Other narrative elements appeared if a plant was associated with classical legend. Artemis, the fierce virgin goddess of hunting (who with a glance could turn a man into a stag), handed artemisia, the most protective of plants, to Cheiron the centaur, who taught mankind

the secrets of plant lore. He reappeared later, galloping across a page bearing centaury which had saved his own life. On another page Homer, in a toga, turned in surprise as a naked Hermes, messenger of the gods, alighted on winged heels, holding an onion (*fig.* 1). In Homer's *Odyssey* the plant that prevented Circe transforming Odysseus into a pig was called moly, given him in his hour of need by Hermes along with supernatural powers against enchantment. The only clues Homer gave to the identity of moly were white flowers, a dark root and great rarity. It was Theophrastus who indicated it was an allium, and therefore endowed with the repellent smell of the onion tribe. Not all pictures were entertaining. If a herbal was incorporated into a medical treatise, then the images of plants provided welcome relief from graphic portrayals of people undergoing enemas and incisions – nowhere more so than the dainty line drawings of arums, mulleins and cinquefoils accompanying the work of John Arderne, a 14th-century surgeon and plantsman of London (see pp. 4, 22, 83 and 117).

It was in the 14th century that the archaic charm of traditional herbals first began to be infused with a dose of realism by artists who were evidently looking at real plants. A similar urge inspired cathedrals and churches to be carved with a variety of realistic leaves, and foliage also dominated the border decorations of illuminated manuscripts. With herbals the impetus to make plants recognisable began in southern Italy, where the medical schools of Salerno, near Naples, were the most advanced in Europe, reflecting the stimulus of Islamic influences. Around 1275 the leading physician Platearius had compiled a tome entitled *Liber de Simplici Medicina Secreta Salernitana* – or alternatively *Tractatus de Herbis* – which was generally known by its opening words *Circa Instans*. The work of Platearius was still based on Dioscorides, but also registered the input of Arabic botany and medicine, as did the inclusion of such plants as jasmine, balm and nigella. The earliest surviving illustrated copy of the *Circa Instans* dates from

about 1300 and, although the plants might seem to lie a little flat on the page, they were imbued with life by a strong sense of the individual patterns formed by their leaves and flowers. Some, like bryony, even extended

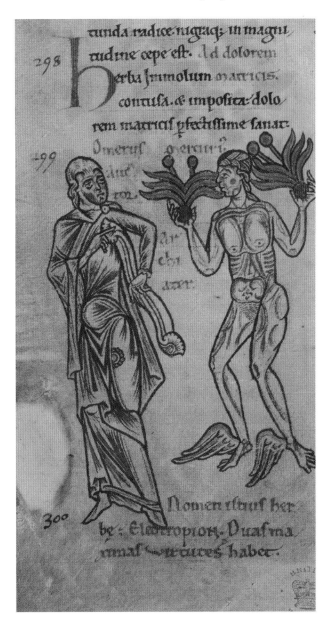

1 *Homer receiving the onion or garlic he referred to as moly from Hermes, the messenger of the gods.*
Tractatus medici de virtutibus herbarum, English, c.1300. Harley MS 1585, f.33v.

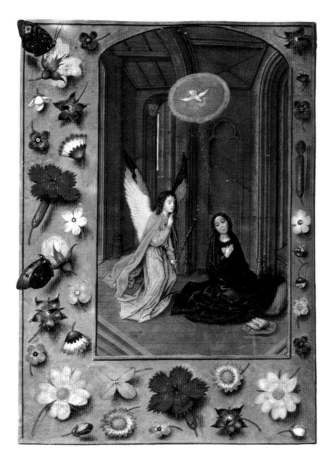

2 The Annunciation with a border of scattered flowers, including wild roses, pinks, daisies, stocks, speedwells, borage, forget-me-nots and woodsorrel. It was customary to produce patterns of size, shape and colour in these flower borders.

Hastings Hours, Flemish, *c.*1480–83: Add. MS 54782, f.73v.

across the page as if still growing. In the ensuing century these influences diffused northwards. A group of Italian manuscripts known as *Tacuinum Sanitatis* pictured people growing and using plants that everyone would recognise. These too were inspired by an Arabic treatise and their title meant 'charts of health' (from the Arabic *taquin*).

By 1400 the centre of medical studies had moved north from Salerno to Padua. Here, in an Italian translation of an Arabic herbal, the illustrator not only espoused realism, but drew his convolvulus romping across the page, and his beans, gourds, vines and asparagus swelling with life. The manuscript graced with this work became known as the Carrara Herbal, after the ruler of Padua, Francesco Carrara, who commissioned it. When he was deposed by the Venetians in 1403 only fifty illustrations had been completed, but they were appropriate to inaugurate the 15th century and its floral outburst. Also belonging to these formative artistic years was the Belluno Herbal, named after the region of the Venetian Alps where it was produced. Although the illustrations lacked the great delicacy of the Carrara Herbal they were lively and aimed to show complete plants with roots and seed cases as well as flowers. The Latin text was once again a version of Dioscorides, but with commentaries in Italian; and the venerable text, with its inevitable bias towards Mediterranean plants, was enlivened by local species, including green hellebores, pale little hemerocallis, various orchids and even an edelweiss.

Despite these stirrings of botanical art, it was not in herbals that the 15th century really expressed its growing fascination with flowers, but in many other forms of art, including the backgrounds of *millefleurs* tapestries, the foregrounds of paintings, and above all the margins of illuminated manuscripts. At last it became abundantly clear that plants were appreciated for their beauty and variety as well as their usefulness. The particular characteristics of different flowers, the curves and markings of their petals, even a sense of their silky texture, were recorded with meticulous care – while daisies and peas, pinks and violas, columbines and roses appeared in every known form and colour. Not that the joy of scientific observation was the reason behind their inclusion in manuscripts. Even plants now considered weeds, like plantain and nettles, were redolent of spiritual meaning. En masse flowers expressed the beauty of God's creation, his ordering of all things rightly, and individually

many had their own specific symbolism. It was therefore appropriate that they should accompany devotional texts and miniatures, especially in Books of Hours. These prayerbooks, designed for the private use of those affluent enough to possess them, and often sumptuously decorated, were based on the observances for the different times of the day, from Matins and Prime to Vespers and Compline, hence the name 'Hours'. Other optional elements included calendars of religious festivals, prayers to particular patron saints, masses for the dead and marks of ownership, such as coats of arms or emblems – the latter regularly taking the form of plants.

Towards the end of the century, from about 1480 onwards, flowers became not simply a part but the dominant feature of the decorative borders of Books of Hours created in the southern Netherlands, especially in the towns of Ghent and Bruges. The style, which was wonderfully innovative, showed the flowers as if they had been plucked from their stems and scattered onto the golden background that framed the page. Here they cast little *trompe l'oeil* shadows as if they were indeed three-dimensional, and a host of insects landed alongside, seemingly lured by their realism (*fig. 2*) On festive occasions flowers were often strewn before the images of saints, or before the Virgin and Christ, as they were carried in procession through the parish. At Pentecost, which celebrated the Holy Spirit descending on the disciples, the drama of that moment was represented by the release of a profusion of petals from on high. The ritual was depicted in the Hours of Margaret of Orleans (*c.*1430), with flowers cascading around the Pentecost miniature, and was alluded to in all subsequent flower-strewn borders. Many religious paintings of the period also showed tributes of flowers, scattered or in vases, before the Virgin and Child.

By 1500 the inspiration of the Ghent-Bruges flower borders had spread to France, where the illuminator Jean Bourdichon worked at the court of Anne of Brittany, queen first to Charles VIII and then to Louis

XII. The Hours of Anne of Brittany, Bourdichon's most lavish manuscript (now in the Bibliothèque nationale in Paris), contained over 350 floral borders, each devoted to a particular plant, which was named in Latin and French. The flowers were still set against golden backgrounds, casting shadows and attracting insects, but these borders marked a further step towards the design of a florilegium – a type of herbal flourishing from the 17th century onwards, which celebrated a collection of plants gathered and recorded for their own intrinsic interest and beauty (rather than any medicinal or religious association). Anne of Brittany was portrayed in a rose garden scene in her Hours and, since she owned some of the earliest glasshouses, she was able to nurture exotics, such as orange trees, pomegranates and peaches, and hers was the first jasmine recorded in France. Among other firsts were snowdrops, sweet williams and celosia – but the range of Bourdichon's illustrations extended beyond ornamental flowers and traditional herbs to the spindleberries of the hedgerows, the bee orchids in the meadows, and the waterlilies on the ponds. In 1508 Anne of Brittany paid Bourdichon for the completed Hours 'for us richly and sumptuously decorated...on which he has spent much time'. Several other members of her court commissioned smaller versions for themselves, of which two are in the British Library. In these Hours the plants were fewer and unnamed, but nevertheless glowed with life.

The pictorial evidence in herbals and Books of Hours was supplemented by all kinds of medieval garden records, from lists to poems, which between them testified to the range of plants and the emotions they aroused. As a prelude to the first great list, promulgated by Charlemagne around 800 and known as the *Capitulare de Villis*, there were small but precious testimonials to how flowers were loved. In the 6th century, a Bishop of Poitiers extolled the scent of violets and spring blossom, and a priest called Severus gathered

lilies to decorate his church. In the 8th century, the Venerable Bede explained why white lilies were a symbol of the Virgin, and Alcuin, Abbot of Tours, cultivated roses for picking, as well as herbs for physic. Charlemagne's *Capitulare* was a decree concerning the crown lands in the cities of his empire (which stretched across France and western Germany and included the Netherlands, Austria, northern Spain and most of Italy). In each city, there should be gardens containing up to a hundred listed flowers, herbs, vegetables and fruit trees. The latter included different varieties of apples, pears, plums and cherries, as well as the more exotic peach, quince, mulberry and fig, which probably flourished only in the more southerly of his territories. The vegetables and pot herbs included a fine array of roots (parsnips, carrots and turnips, as well as the onion tribe); also salads and pulses; primitive types of cabbage and spinach; gourds, cucumbers and melons. The *cardones* listed in the *Capitulare* could have meant globe artichokes or cardoons, but were probably teasles (the first clear reference to artichokes did not appear until 1460, when they grew in the gardens of the Villa Strozzi in Florence). Charlemagne's listings of herbs naturally corresponded to those found in herbals, with a few inexplicable omissions such as betony, agrimony and lavender, and a few typical uncertainties of naming – *febrifugian* was either feverfew or centaury, *dracunculus* either dragon arum or tarragon, *solsequiam* either marigold or chicory.

Within a few years of the *Capitulare*, a plan preserved at St Gall in Switzerland showed the proposed layout for a monastery and its three gardens. The *herbularius* near the infirmary contained sixteen long, thin rectangular beds with named herbs, including sage, fennel, tansy, mint and rosemary, together with irises, lilies and roses. The larger *hortus* or kitchen garden had eighteen beds of vegetables and more herbs, some primarily medicinal, like poppy. Third, the monks' cemetery, planted ornamentally around a central cross, served also as the orchard. Altogether about half the plants of the

Capitulare were mentioned in the St Gall plan, and all the fruit trees, not forgetting medlars. A monk from St Gall, Walafried Strabo, added to the horticultural material of the period a Latin poem composed around 840 and entitled *Hortulus*. Later he became Abbot of Reichnau on Lake Constance, but immediately before he wrote *Hortulus* he had been a tutor at the imperial court. His description of cutting a melon, 'the spoil and chief pride of a garden, a choice and delectable feast…slipping down the throat in a cool stream to refresh the belly', fitted the archetype of a sensuous prelate, but this was belied by his descriptions of real gardening:,

When the days grew longer and milder, when flowers and herbs were stirred by the west wind, when green leaves clothed the trees, then my little plot was overgrown with nettles. What was I to do? deep down the roots were matted like basket work. I prepared to attack armed with the tooth of Saturn [a pickaxe?] and tore up the clods and rent the clinging network…I planted my seeds and must water them, letting the drops fall through my fingers, for the impetus of a full stream from the water pot would disturb my seedlings.

The first English plant list can be extrapolated from the Latin dictionary created by Aelfric in 995, which included over 200 trees and herbs with their equivalent Anglo-Saxon names, though some, like palm and cedar, were biblical concepts, not plants that grew in England, and others, like peaches, figs and mulberries, were probably known only to the elite, or pilgrims who travelled through Europe and beyond. The reputation of many plants reached further north during the Middle Ages than their actual distribution. But there were certain periods of warmer climate when experiments with exotics would have been feasible, if shortlived. Such was the case during the 13th century when the emperor Frederick II, enchanted by the vegetation surrounding his court in Sicily, built hanging gardens on

the buttresses of his castle at Nuremberg. And Archbishop Engelbert of Cologne created gardens of such rare plants that the ringleaders of a citizens' revolt succumbed to curiosity and accepted his invitation to visit, whereupon he imprisoned them. This fascination with exotics, feeding into garden literature, was also evident in the work of the three great medieval encyclopaedists – Alexander Neckam, Bartholomew Anglicanus and Albertus Magnus. Neckam's works were in circulation by 1200 and remained influential for the next three centuries. He named in total about 140 plants and trees, which again included possible introductions to England, like acanthus, mandrake, borage, myrtle, pomegranates, narcissus and French lavender. Even the palms, lemons and oranges Neckam mentioned may briefly have been reared in England as little shrubs. (Richard the Lionheart who, with his entourage, spent most of his reign in warmer climes, was Neckam's foster brother and may have brought him challenging seeds to grow.)

By 1240 the second great English encyclopaedist, Bartholomew of Glanville, had completed his work that listed over a hundred plants together with cultivation notes – that the removal of suckers from garden roses would prevent them reverting to their wild form, and how to create a smooth lawn. But he waxed more lyrical over flowery meads, those colourful areas of grass beloved of medieval poets and painters, 'with herbs, grass and flowers of diverse kinds, that for their fairness and green springing it is said that meads laugh' (figs 3 and 4). A century later Boccaccio set the garden of the storytellers in *The Decameron* around 'a meadow plot of green grass jewelled with a thousand flowers', while Chaucer produced a whole series of descriptions, including 'the small, soft, grass that was with flowers sweet emboidered all'.

Albertus Magnus, Count of Bollstadt, completed his encyclopaedia by 1260 with a treatise on vegetables and plants listing twice Bartholomew's total, and further enhanced his reputation for horticultural wizardry by creating a garden that flowered in midwinter. How this was done was not explained, but his description of a green space 'of no great utility or fruitfulness but designed for pleasure' was the archetype of a medieval garden. A square of grass was enclosed by beds of sweet-smelling herbs (specifically sage, basil and rue) mixed with favourite flowers (irises, lilies, roses, columbines

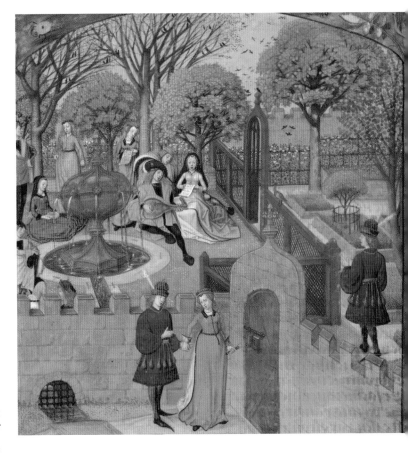

3 *This garden scene is well evoked in Chaucer's* Franklin's Tale:
May had painted with his soft showers
This garden full of leaves and flowers.
And craft of man's hand so curiously
Arrayed had this garden truely,
That never was there garden of such price
But if it were the very paradise
Th'odour of flowers and the fresh sighte
Would have made any heart for to light.
Romance of the Rose, Flemish, c.1485(?): Harley MS 4425, f.12v.

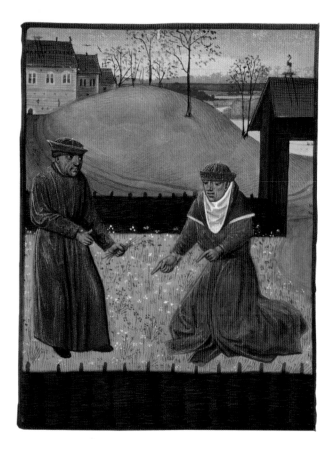

4 *In a medieval herb garden, enclosed by a wattle fence, the Italian horticulturalist Pietro de' Crescenzi instructs a pupil on gathering herbs.*
Rustican due cultivement des terres/Liber ruralium commodorum *by Pietro de' Crescenzi of Bologna, southern Netherlands (Bruges), 1473–83: Royal MS 14 E. VI, f.157.*

and violets). In the centre was a fountain of water in a stone basin, with seating at the edges of the grass between the flowerbeds, on raised turf benches 'flowering and lovely'. The garden was lightly shaded by fruit trees or vine arbours, with evergreen bay or cypress, allowing the breezes to pass between. In 1305 Pietro de' Crescenzi of Bologna produced his *Liber ruralium commodorum*, expanding on the gardening sections of the preceding encyclopaedias and further popularising their contents, again with hints of exotic warmth, like suggesting that pomegranates made the best hedges.

Inspiration filtered through Europe from the Islamic world. As well as garden concepts (including botanic gardens), and such practicalities as the design of fountains, and curative herbs and herbals, there were also fruits and flowers from the East, pomegranates among them. Plants first brought into cultivation during the Roman Empire were reintroduced in the Middle Ages through the Islamic areas of Spain and southern Italy. Other plants were new – saffron, jasmine, and hollyhocks among them and there were new forms of familiar flowers including white iris, red and tawny wallflowers and double carnations. In listing and grouping the plants that flourished in Islamic Spain, Ibn Bassal, superintendant of the botanic gardens of Toledo and later Seville, provided the first important text around 1080 with his *Book of Agriculture*. This also methodically explained methods of dealing with diseased orange trees, irrigating, fertilising, planting, grafting, pruning. A century later the naturalist Ibn al-'Awwam brought the total of species listed up to 160 and added chapters on design - shaping the garden into squares for planting, with avenues, pools and rills of water between, and the all-important shade trees. Ibn al-'Awwam also mentioned peacocks, another exotic that found its way northwards to enhance 15th-century European gardens, sped on its way by the Islamic legend that it was a bird of paradise able to consume the serpent. In the mid-14th century, when the Court of Myrtles was being constructed in the Alhambra at Granada, the Andalusian author Ibn Luyun wrote a poem known as the *Andalusian Georgics*, again listing and categorising over 150 species of plants, and dwelling pleasurably on the plan for a perfect garden, to be viewed in every direction from a pavilion at the centre.

Travelling scholars, including a significant contingent of Jews, helped to disseminate the real and intellectual fruits of Islamic horticulture, and intermarriage between the royal houses of Europe also contributed. In 13th-century England, Eleanor of

Provence, who married Henry III, and Eleanor of Castile, wife of Edward I, both brought in gardeners from their native lands, planted vines and fruit trees on a grand scale (including peaches and quinces) and created herbers, trellises, lawns, pools and little bridges – all detailed in the accounts of the works at Westminster, the Tower of London and elsewhere. The following century the most notable garden chronicler of medieval England, Friar Henry Daniel, shared a passion for plants with Queen Philippa, wife of Edward III. From her royal herber he acquired new plants, including rosemary and pinks, for his own garden at Stepney (where he grew an astonishing 250 'sorts of herbs'). Many herbs were collected on his journeys around England, made primarily because Daniel was a doctor in search of cures; but his descriptions always displayed his fascination with the regional names, habitats and growth habits of plants (cranesbill, for instance), and above all their irresistible beauty. Daniel knew a circle of other botanists who consulted one another, 'many wise men in this faculty…and namely good gardeners', 'a Christian man that learned among Saracens' and 'a Jew new turned to the faith'. Daniel must also have known the royal physician John Bray and the surgeon John Arderne, both botanists. Maybe he also compared notes with Chaucer, whose love of gardens and knowledge of plants was manifest in his poetry. In *The Knight's Tale* Chaucer listed the trees of 14th-century England, and in *The Nun's Priest's Tale* he listed purging plants. In *The Legend of Good Women* he mentioned 'a little herber that I have' with turf benches 'thick set and soft as any velvet'. Lines from other poems expanded the picture of 'a very paradise', shaded with 'blossomy boughs', and the grass 'powdered as men had it paint, with many a fresh and sundry flower'.

The *Romance of the Rose* was Chaucer's version of the great 13th-century French allegory by Guillaume de Lorris, where the lover gained entrance to a high-walled garden to seek arduously for the rose which symbolised his lady's love (and possibly some greater wisdom) (*fig. 3*). In the French original the trees and roses of the garden had been brought 'de la terre des Sarrasins' which Chaucer rendered as 'the land Alexandryn'. Both poets were again displaying that enduring fascination with exotics, no doubt because they were in fact so rare. The medieval French poet Eustache Deschamps, in a verse praising Chaucer, said he had 'long ago laid out a garden for which he asked for plants', so he can be imagined as he travelled abroad on diplomatic missions looking out for unusual specimens. Both Friar Henry Daniel and the *Menagier* (merchant) of Paris (who wrote a domestic treatise for his young wife in 1394) went into serious detail over the taking and transporting of cuttings. But the 14th-century descriptions of the royal gardens at St Pol in Paris are a reminder that lavish displays depended mainly on old favourites – vine arbours and plantations of fruit trees. At St Pol in 1398 Charles VI ordered the planting of 1000 cherry trees, over 400 vines, about 100 each of pears, plums and apples, and twelve paradise apples, meaning quinces. For evergreens there were eight bay trees, and for the flower beds 300 bundles of red and white roses, 300 lily bulbs and 300 iris.

On a smaller scale, when poets and painters set the scene, they generally chose the flowery mead, the rose bower and the herber, and the most familiar plants – as in *The Tale of Beryn*, written by a contemporary of Chaucer, when the Wife of Bath took the Prioress by the hand,

…forth then they wend,
Passing full softly into the herbery,
Where many a herb grew for stew and surgery,
And all the alleys fairly trimmed and railed,
The sage and hyssop all fretted and staked,
And other beds by and by full freshly dight,
For comers to that place a sportful sight.

Let's follow them.

Elebore nigre

Valariul melion .i. ells nigre
Vina toñ. karbech khuebech.
Polizon / Melampolio

Origanu nã

Origanui potatu

Origanus

golena

pparato ells
nigri

Descriptions of Plants

Acanthus

Acanthus mollis

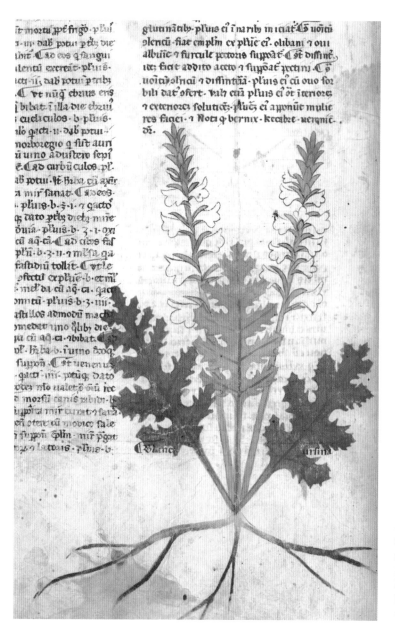

ACANTHUS was to be found throughout medieval Europe, although not necessarily in gardens. Carved patterns of acanthus leaves were inherited from classical architecture, notably in the decoration of Corinthian columns. According to legend, the Greek architect Callimachus adopted this motif when he saw acanthus growing from under a gravestone, full of vigorous new life, and the resurrection symbolism lingered with acanthus, giving added reason for its use in Christian art. From the 11th century, acanthus leaves were reworked in Romanesque and then Gothic styles, often twisted to frame people and monsters, and by the 15th century they superseded vines as the dominant leaf pattern decorating the margins of illuminated manuscripts (see page 52).

LEFT *The plant's Old French name* blanc ursina (*literally 'white bear'*) *linked acanthus with bears because its flower bracts tear the flesh. (*Acanthus mollis, *shown here, is less spiny than* Acanthus spinosus.*) Its few medicinal uses were for sharp pains like gout and burns. The old English name, bear's breeches, may have been based on a mistranslation of* blanc *into 'brank', an old word for 'breeches'.*
Circa Instans, Italian c.1300: Egerton MS 747, f.14v.

Anemone and Adonis

Anemone coronaria and Adonis annua

CORONARIA was a name given in classical times to flowers used, as anemones were, in festive garlands. The closely related red adonis flowers were used in ancient rituals associated with the divinely handsome Greek youth Adonis, who captivated Aphrodite herself. Re-enactments of his violent death, followed by mourning and a joyous springtime resurrection, prefigured the Christian Easter. When a 12th-century Bishop of Pisa ordered earth from the Holy Land to be spread on the city's Campo Santo (Holy Ground or cemetery), and was astonished to see a miraculous carpet of red anemones appear the following Easter, the legendary blood-red of the adonis was probably reasserting its significance.

RIGHT *Anemones were not unknown, but they seldom featured in medieval records, and only the closely related adonis (seen here) were illustrated.*
Bourdichon Hours, French, early 16th century: Add. MS 35214, f.44.

Apples
Malus domestica

RECENT research has confirmed that apples are worthy of the myths they have inspired. The Biblical claim that God planted them 'eastwards in Eden' was geographically correct because *Malus sieversii*, the genetic ancestor most closely related to the domestic apple, grows wild in Kazakhstan, to the north of the Tien Shan, or heavenly mountains. Over millennia their seeds were dispersed by birds and animals, who chose the sweetest fruit, and finally by humans as they travelled along the ancient trade routes known as the silk roads. As apples arrived in Europe the Greeks wove fresh myths about the distant garden of the Hesperides where golden apples grew. On a more practical level, the Greeks learnt the oriental technique of grafting the stems of improved varieties of apple onto the rootstock of native trees to help them adapt, a process repeated throughout Europe by the Romans.

LEFT *Described by Chaucer as 'blossomy boughs', fruit trees were regarded as an essential feature of medieval gardens.*
Bourdichon Hours, French, early 16th century: Add. MS 35214, f.67.

ABOVE *In France and England apples evolved with characteristic diversity of taste and use.*
Bourdichon Hours, French, early 16th century: Add. MS 35214, f.130.

Artemisia
Artemisia vulgaris and related species

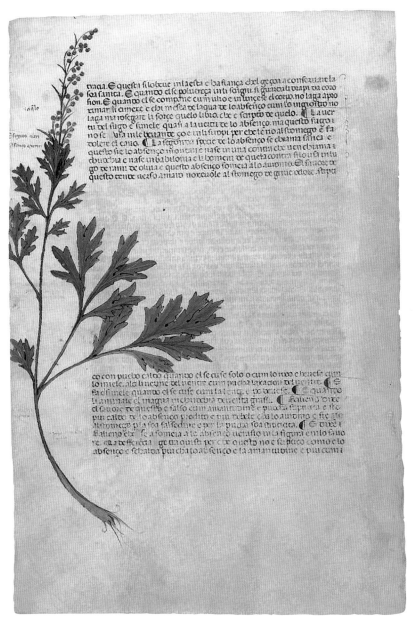

ARTEMISIAS are distinctive not for their flowers, which are the most insignificant of the daisy family, but for their aromatic foliage which was considered able to repel everything from fever and nausea to worms, insects and dragons; hence the old names mugwort (*Artemisia vulgaris*) – 'mug' being an old word for 'midge' – wormwood (A. *absinthium*), garderobe (A. *abrotanum*) and esdragon (A. *dracunculus*), which in English became tarragon. Artemisias were worn as charms, suspended over doorways, and carved among the leaf decorations of medieval cathedrals – especially around the heads of 'green men', whose prime function was to ward off evil. Herbals depicted the goddess Artemis handing the plant, to which she gave her name and her great protective powers, to the centaur Chiron who taught the Greek heroes the secrets of wisdom and medicine (see pp. 8–9, 35).

LEFT *The life-saving tonic powers of mugwort or muggons featured in a Scottish ballad: 'If they wad drink nettles in March and eat muggons in May /Sae mony braw maidens wadna gang to the clay.'*
Carrara Herbal, Italian, *c.*1400: Egerton MS 2020, f.12v.

Arum

Arum maculatum and *Dracunculus vulgaris*

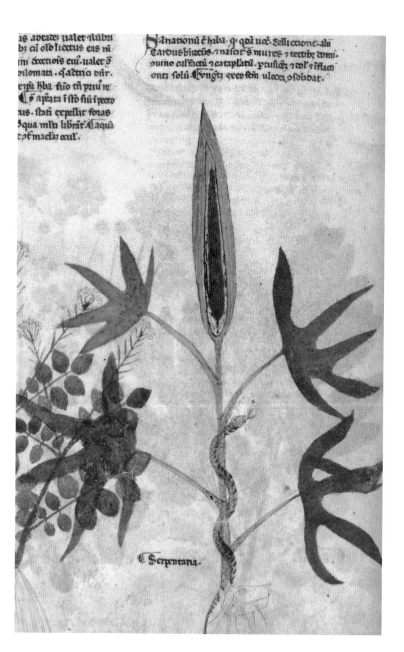

NO NICKNAME given to arums, with their sexy purple spadix, was innocent. Lords-and-ladies signified copulation, cuckoo-pint was short for pintle, meaning 'penis'. If cuckoo suggested the season of their flowering, it probably came originally from the Latin *cucullus*, meaning 'cowl', because of the spathe containing it. Hence the links with priests – names like priest-in-a-pulpit or priest's pintle – and in French *membre d'eveque*, signifying a promotion to the bishopric. The flowers exude a smell of putrefaction designed to lure flies for pollination purposes, mild in a small arum, but a powerful stench when the large dragon arum unveils its spadix. Arums are poisonous, but their roots were processed into a starch, like arrowroot, and used for snakebite and other medicinal purposes, including aphrodisiacs.

ABOVE Arum maculatum, *a small line drawing illustrating the work of a London surgeon.* Treatise of John Arderne, English, mid-14th century: Add. MS 29301, f.53.

RIGHT *Dragon arum, a Mediterranean plant, was an antidote to snakebite and named* Serpentaria, *because its stems are patterned like snakeskin.* Circa Instans, Italian, c.1300: Egerton MS 747, f.93v.

Balm and Melissa

Commiphora and *Boswellia* trees and *Melissa officinalis*

MEDIEVAL Christians knew of Jeremiah's lament, 'Is there no balm in Gilead?'; and also that Joseph's brothers sold him to merchants heading for Egypt with camels bearing balm and spices. Like frankincense and myrrh (the gifts of Sheba to Solomon and of the Three Kings to Christ), balm came from the resin of *Commiphora* and *Boswellia* trees, which provided healing and scented ointments. Dioscorides called it *opobalsamum*, and of the two main balm (or balsam) trees, *Commiphora opobalsamum* is now known as Mecca balsam, while balm of Gilead is called *C. gileadensis*. For lack of real balm, European herbalists sought substitutes, especially the bee plant (*Melissa officinalis*). The leaves contain balsamic oils, which make excellent antiseptic dressings and medicines.

ABOVE Melissa officinalis, *lemon balm, easily grown throughout Europe.*
Circa Instans, Italian, c.1300: Egerton MS 747, f.64v.

RIGHT *The resin of balm* (Commiphora) *being gathered in a walled garden, a practice imitated from the Islamic world.*
Circa Instans, Italian, c.1300: Egerton MS 747, f.12.

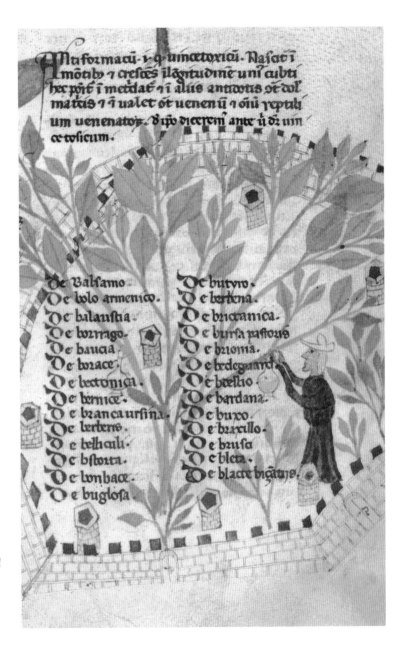

Beans and Broadbeans
Vigna species and *Vicia faba*

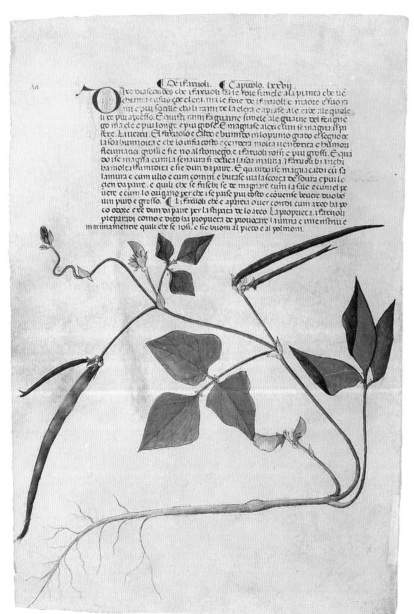

BEANS were a major sustaining food of the ancient world and were placed in graves to help the soul on its journey to the afterlife. Europe inherited these concepts along with the beans, which sometimes appear in paintings of the Last Supper or around a miniature of the Entombment of Christ. An Italian dish named *Fava dei Morti* (beans of the dead) and the English Twelfth Night cake, which contained a hidden bean to designate the mock king of the celebrations, hint at old rites of passage. Some disliked beans for more mundane reasons. The Greek physician Dioscorides thought that they caused flatulence and bad dreams. Others, seeing how important beans were to humble folk and their livestock, regarded them as coarse, inferior food.

LEFT *Vigna beans were the Old World equivalent of* Phaseolus *beans (French beans and scarlet runners);* Phaseolus *beans arrived in Europe from the New World in the 16th century and largely replaced* Vigna *beans.*
Carrara Herbal, Italian, c.1400: Egerton MS 2020, f.56v.

ABOVE *Broad beans,* Vicia faba, *were the main beans of ancient and medieval cultivation, and of the bean feasts held for the dead.*
Circa Instans, Italian, c.1300: Egerton MS 747, f.41.

Betony
Stachys officinalis

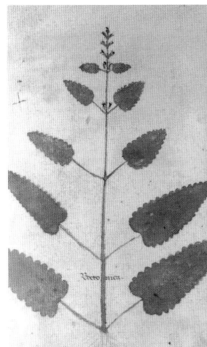

IN THE Middle Ages betony was considered a most powerful healing herb, used in the legendary forty-seven remedies compiled by Caesar's doctor. No physic garden was without its slender, pink-flowered stems, valued far more than mint, thyme or other related plants. Betony is still a herbal tea, and for those mysterious complaints, like migraine, stress and digestive disorders that baffle conventional medicine, it could well, for some, still prove miraculous.

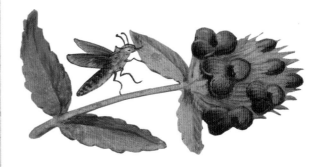

LEFT *Illustrations of betony, which featured in every herbal, were usually very stylised.*
Circa Instans, Italian, c.1300: Egerton MS 747, f.14r.

ABOVE *The plant's tiny pink flowers often appeared in the flower-strewn borders of the Ghent-Bruges Hours.*
Bourdichon Hours, French, early 16th century: Add. MS 35214, f.47.

Blackberries and Raspberries
Rubus fruticosus and *R. idaeus*

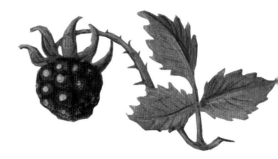

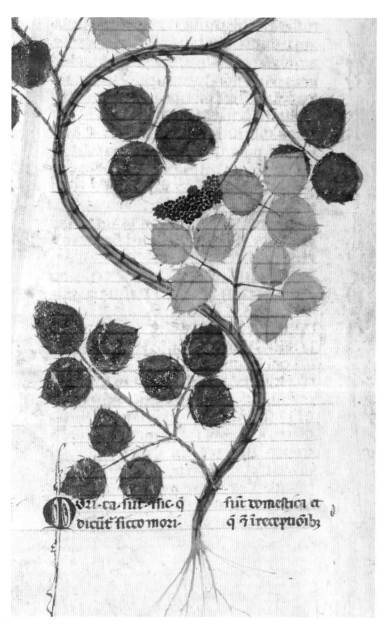

BLACKBERRIES and raspberries were gathered by the earliest inhabitants of Europe, and archaeological finds include shrivelled corpses with pips in their stomachs. Classical writers gave them literary status: Ovid included blackberries in his description of the Golden Age, and Pliny claimed raspberries grew on Mount Ida, a home of the gods. Herbals recommended blackberries for various inflammations, including tonsilitis and rheumatism, often accompanied by incantations, or passing the afflicted under an archway of brambles rooted at either end. Over unquiet graves, brambles were woven to keep the contents within. The less vicious raspberry was attributed milder curative properties and named after *raspis*, a sweet red wine.

LEFT *In herbals the brambles of blackberries were considered integral to the cure, and were therefore emphasised.*
Circa Instans, Italian, c.1300: Egerton MS 747, f.64v.

ABOVE *The naming of raspberries (previously called hindberries) after a French wine, coincided with the introduction of garden cultivars in the 15th century.*
Bourdichon Hours, French, early 16th century: Add. MS 35214, f.22.

Bluebells

Hyacinthoides non-scripta syn. Scilla non-scripta

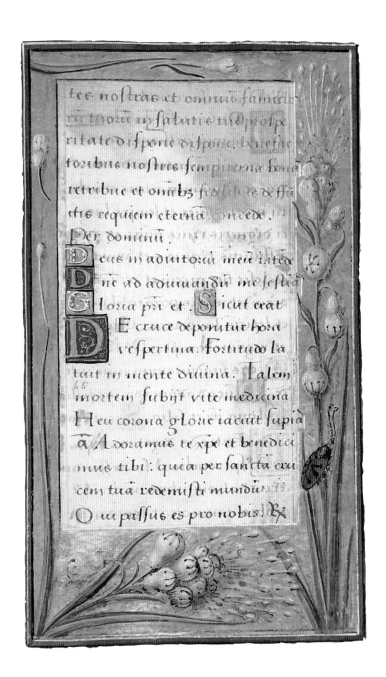

ORIGINALLY, bluebells were just one of a group of plants named hyacinth, said to be inscribed with the letters AIAI (or 'alas'), which was the dying lament of the Greek youth Hyacinth accidentally killed by Apollo. Since the innocent bluebell bears no such mark, it was named *non-scripta*. This was also apt because bluebells remained unrecorded until the 14th century, when Friar Henry Daniel described them as 'lilies of the wood…like daffodils but blue'. From their bulbs a medieval glue was extracted, variously used for setting feathers on arrows, bookbinding and starching.

ABOVE *When bluebells appeared in illuminated manuscripts, their colour sometimes reflected the ultramarine blue of the Virgin's gown.* Huth Hours, Flemish, c.1480–85: Add. MS 38126, f.82v.

RIGHT *Tassel hyacinth (Muscari comosum), a species of grape hyacinth native to France and Germany, is closely related to bluebells.* Bourdichon Hours, French, early 16th century: Add. MS 35214, f.74.

Borage and Comfrey
Borago officinalis and related species

BORAGE gave its name to the plant family *Boraginaceae*, of which several bore the Latin suffix *officinalis*, reserved for vital medicines. Borage was credited with lightening the heart as well as the taste buds, and is still used in drinks. Lungwort (*Pulmonaria officinalis*), with leaves speckled white like diseased lungs, yielded a mucilaginous infusion administered for coughs. Comfrey (*Symphytum officinalis*), which is even stickier, was applied to swellings, bruises and even broken limbs; both comfrey and symphytum are words for uniting. Alkanet (*Anchusa officinalis*) was also curative, but its major use was the reddish dye yielded by its roots, and its name was a corruption of the Arabic *al-henna*.

LEFT *Comfrey (top left and right) has a range of flower colours, but predominantly produces shades of purple.*
Circa Instans, Italian *c.*1300: Egerton MS 747, f.30v.

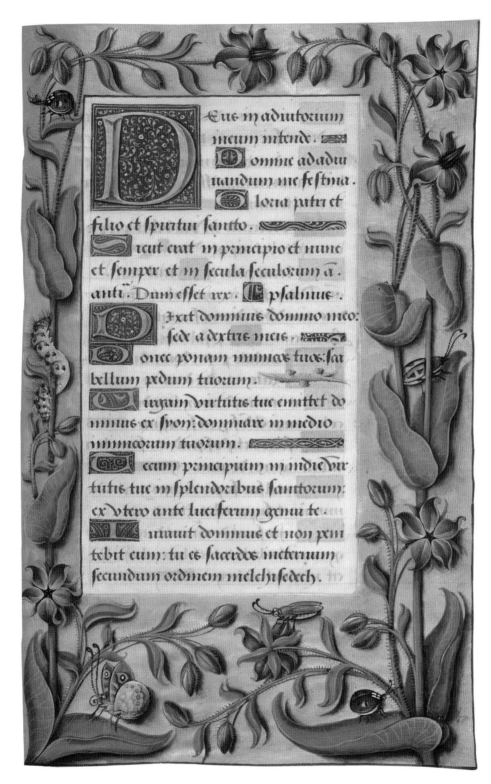

LEFT *Borage and related flowers are usually blue, but hints of pink and white earned names such as Abraham, Isaac and Jacob, and these colour variations occasionally appeared in manuscripts.* Bourdichon Hours, French, early 16th century: Add. MS 18855, f.51.

Broom

Cytisus scoparius

THE MEDIEVAL NAME *planta genista* included broom, petty whin (*G. anglica*), dyers greenweed (*Genista tinctoria*), and gorse (*Ulex europaeus*); but any passing cavalcade plucking sprigs as emblems, or for recognition on the battlefield, would have chosen broom since the others are prickly. The Dukes of Anjou and their descendant Henry II of England took Plantagenet as their family name, but the broompod device remained predominantly French. After 1234, when Louis IX established a knightly order comparable to the Garter, the Cosse de Genet became a badge of the highest honour, and in 1396 Richard II adopted broompods as an emblem not because he was a Plantagenet, but because he married a French princess. The repeated appearance of broom in the Book of Hours made in Paris for John, Duke of Bedford, Regent of France, represented both French and English royalty. The duke ruled on behalf of his infant nephew Henry VI, who claimed the French throne, and instituted the regime against which Joan of Arc later rebelled.

ABOVE *Rabbits often appeared in manuscript borders, but here the French illuminators may have dared to risk an element of subversion under the royal plant.*
Bedford Hours, French *c.*1423: Add. MS 18850, f.65.

Bryony

Bryonia dioica

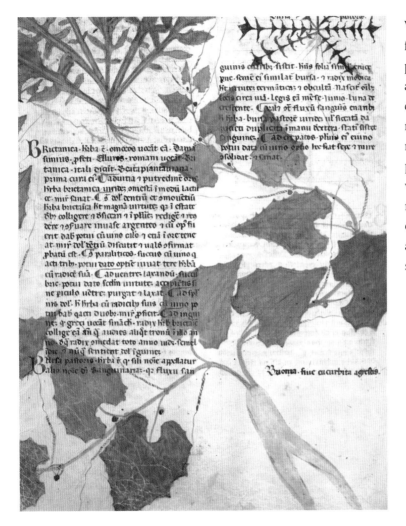

WHITE bryony was valued as a substitute for mandrake, for which its forking roots provided a cheaper, home-grown alternative with none of the attendant dangers in uprooting it (see p. 78). Being a member of the gourd family, bryony bears no other resemblance to mandrake. It is poisonous, but pedlars of fake mandrake were selling it for luck and fertility charms, rather than consumption. The contrived charm figurines were known as 'puppettes' and assumed quasi-official status when suspended in apothecaries' shops.

ABOVE *This bryony, with its characteristic forked root, and the stems spreading across the page, is an early example of a more realistic style of herbal illustration.*

Circa Instans, Italian, c.1300, Egerton MS 747, f.16v.

Campanula
Campanula trachelium and related species

PILGRIMS carried bells to announce their presence along narrow country roads, and in Italian herbals bellflowers were named *Herba san Cristoforo* after the patron saint of travellers. On arrival at their shrine, pilgrims bought badges, which they wore as souvenirs and tokens of blessing. These might be stamped with St James of Compostela's shell or St Catherine's wheel, but many shrines also sold badges in the form of a pilgrim's hand-bell. At Canterbury these were inscribed *Campana Thome* after Thomas Becket. The original Canterbury bell was not *Campanula medium* but the nettle-leaved bellflower (*C. trachelium*), or throatwort, well known also as a herbal cough cure.

ABOVE *With its characteristic bell-shaped flowers, campanula takes its name from the Latin for 'little bell'.* Circa Instans, *Italian, c.1300: Egerton* MS *747, f.108v.*

RIGHT *The nettle-leaved throatwort (Campanula trachelium) secretes a yellow latex, which, by the doctrine of signatures, rather disgustingly reinforced its link with respiratory afflictions.* Bourdichon Hours, *French, early 16th century: Add.* MS *35214, f.51v.*

Campion
Silene latifolia, S. dioica and related species

CAMPIONS featured often in medieval gardens, providing shades of white and pink, augmented by the deep magenta of rose campion (*Lychnis coronaria*). The latter was introduced from the Holy Land and provided lamp wicks from its furry leaves, hence the name *lychnis*, meaning 'light'. There were also the more curiously shaped bladder campions (*Silene vulgaris*), and the pretty serrated petals of ragged robins (*L. flos-cuculi*). Country names for campions, like wake robin, wild williams, red jack and bachelor's buttons, alluded to their use in flirting games when girls hid flowers in their clothes and invited the man of their choice to discover them. Maximilian of Austria tried this at his betrothal to Mary of Burgundy in 1475, on which occasion the hidden flowers were pinks. If the search was successful the 'buttons' were presumably worn with pride.

ABOVE *A bladder campion makes a rare appearance in the Ghent-Bruges Hours.*
Huth Hours, Flemish, c1480–85: Add. MS 38126, f.82v.

RIGHT *The decorative flowers of red campion (S. dioica) often appeared in the borders of 15th-century manuscripts.*
Bourdichon Hours, French, early 16th century, Add. MS 18855, f.65v.

Carline thistle
Carlina acaulis

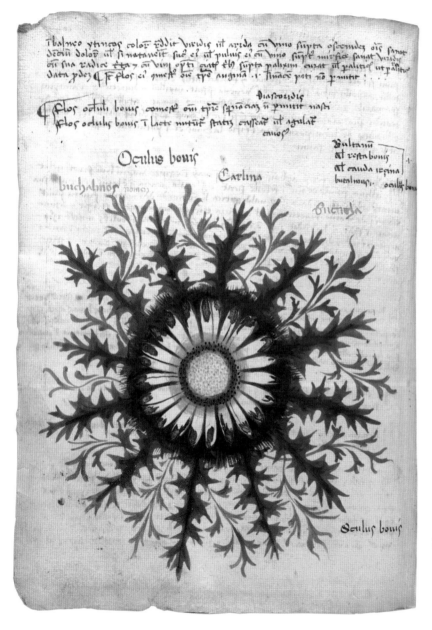

CARLINE thistles were named after Charlemagne who, praying desperately for deliverance from a pestilence that had struck thousands in his army (perhaps a virulent strain of flu), saw an angel shoot an arrow at a spot where a carline thistle grew. With it he cured his men – like many composites, it is a febrifuge (used to reduce fever). The legend also enhanced the protective reputation of the flowers, which were hung over doorways and barns. Here, looking like sunbursts, they continued to expand in dry weather and close in wet, adding to their aura of magic. The name given in the Belluno Herbal, *Oculus bonus*, suggests the flower also represented the protective, all-seeing eye of heaven, an image widespread in the early churches of southern Europe.

LEFT *A striking view of a carline thistle flowering in the centre of its leaves, or possibly illustrated as it would have appeared hung over a doorway.*
Belluno Herbal, Italian, early 15th century: Add. MS 41623, f.97v.

Centaury and Cornflower

Centaurium erythraea and *Centaurea cyanus*

THE CENTAUR Cheron, credited with explaining the properties of plants in ancient Greece, remained the symbol of this vital knowledge all through the Middle Ages. Two flowers were named after him, although they were not related. Pink-flowered centaury, still valued as an astringent tonic, was used for treating fever, poisoning and disorders of the blood (Cheiron having cured himself with centaury after being shot with a poisoned arrow). The other *centaurea*, cornflowers – gracing cornfields with ultramarine blue, but blunting sickles with their stalks – were believed to have similar medicinal properties. Cornflowers were popular with manuscript illuminators, providing pretty shapes of vivid blue in their decorative borders.

ABOVE *Centaury's extreme bitterness, which made it a natural tonic, gave rise to its Latin name* Fel terrae *(gall of the earth). It was also known as* febrifuga *and feverwort for its fever-breaking powers.*
Bourdichon Hours, French, early 16th century: Add. MS 35214, f.45v.

RIGHT *Cornflower, traditionally worn as a symbol of love in flirting games, was popularly known as bachelor's button, basket flower and Boutonnière flower.*
Bourdichon Hours, French, early 16th century: Add. MS 35214, f.129v.

Cherries and Plums

Prunus avium and *P. domestica*

CHERRIES were the first fruit trees to ripen each year, and midsummer fairs, with all their attendant romping and regret, were often called cherry fairs, which by the 13th century had become a symbol of transience – 'This life I see is but a cherry fair'. Similarly, a painting of Christ as a child reaching out for cherries dangled towards him was a poignant image, not so much of temptation, but of his bloodstained death. Plums escaped such symbolism but, like cherries, they were familiar as wildlings – sloes and bullaces – and as orchard graftings. Grafting enabled the introduction of more succulent species of both cherries and plums from the Middle East.

LEFT *Bullaces and other wild plums were native to Europe, while damsons, when they were introduced into Europe, were named after Damascus. They may not have originated there but it was a rich Arab entrepôt.* Bourdichon Hours, French, early 16th century: Add. MS 18855, f.43.

OPPOSITE *The Romans first brought sweeter cherry trees into Italy from Asia Minor, and they subsequently spread throughout Europe.* Bourdichon Hours, French, early 16th century: Add. MS 18855, f.63.

Cinquefoil and Lady's mantle

Potentilla reptans and *Alchemilla mollis*

THE WORD *potentilla* means 'little powerful one'; and *alchemilla* referred to alchemy, because the metallic gleam of water droplets on the leaves suggested experiments with mercury and the search for gold, power or wisdom. The English name cinquefoil came from the French *cinque feuilles*, meaning 'five leaves'. In herbals cinquefoil was called *pentaphyllon*, the Greek for 'five-leaved', which, like the pentangle, signified power. This was why medieval border forts were built as pentagons. The cinquefoil leaf was Christianised by using it to symbolize the hand of Mary (just as *alchemilla* became lady's mantle) or the five wounds of Christ – and these plants were used above all as wound worts. When gunshot wounds were added to human afflictions, the closely related agrimony (*Agrimonia eupatoria*) became a principal ingredient of the healing *eau d'arquebusade*.

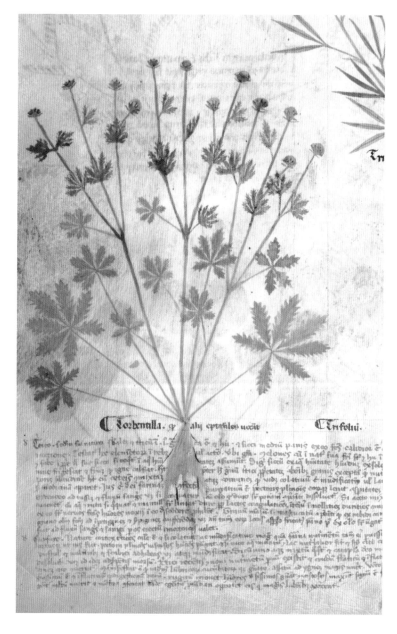

ABOVE *Cinquefoil featured not only in every herbal, but in medieval church carvings.*
Circa Instans, *Italian, c.1300, Egerton* MS *747, f.78v.*

RIGHT *Tormentil (Potentilla erecta) was named after the torments it relieved.*
Circa Instans, *Italian, c.1300, Egerton* MS *747, f.102v.*

Clover and Vetch
Trifolium pratense and related species

CLOVERS and trefoils were associated throughout Christendom with the Trinity and inspired many foliar patterns both in church carvings and manuscript illumination. The Irish shamrock (*Trifolium dubium*), a pagan good luck charm, was sanctified by St Patrick, who held up a leaf to explain Father, Son and Holy Ghost, three persons in one God. Other old names for clover, including honeysuckle and honeystalks, referred to the sweet nectar at the base of each flower. Vetch (*Vicia sativa*), which has flowers like miniature sweet peas, is not a trefoil but, like clover, was valued for forage.

ABOVE *In the Hours of Anne of Brittany, Bourdichon named clover* souppes en vin, *since the flowers were used to take off the vinegary edge wine often had. In English 'sops in wine' was mainly applied to pinks.*
Bourdichon Hours, French, early 16th century: Add. MS 18855, f.73.

RIGHT *Vetch, an exquisite example of a flower study from the Ghent-Bruges Hours.*
Huth Hours, Flemish, c.1480–85: Add. MS 38126, f.17.

Columbine

Aquilegia vulgaris

COLUMBINES were associated with birds. The likeness of the petals to fluttering wings, and the spurs above the petals to their curving necks and heads, linked them to Christ's spirit in the form of an eagle (*aquila*) or the Holy Spirit in the form of a dove (*columba*) – hence the two names *aquilegia* and columbine. Their purple-blue was regal, but also a colour used in mourning; and their common French name *ancolie* was treated as an abbreviation for *melancholie*. The heraldic 'branche of collobyns blue, the stalk vert' became an emblem especially favoured by widows. In Christian art the sorrows of Mary were reflected in purple flowers, especially columbines. But 15th-century manuscript illuminators were fascinated by the variations of flowers, and therefore started to include white and pink columbines, and double forms, moving away from symbolism towards scientific observation.

ABOVE *Columbines were first mentioned in the plant list attributed to the German Abbess Hildegard of Bingen, c.1150.* Huth Hours, Flemish, c.1480–85: Add. MS 38126, f.29v.

RIGHT *Alongside the miniature of Christ's entombment, columbines were flowers of mourning.* Isabella Breviary, Flemish, 1497: Add. MS 18851, f.124.

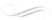

Convolvulus
Calystegia sepium

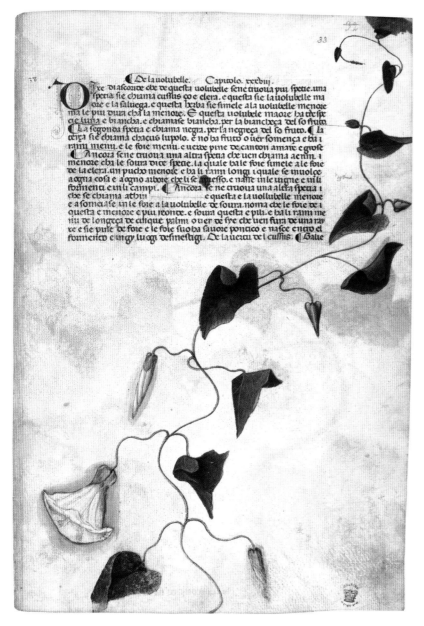

CONVOLVULUS richly deserved such traditional names as bindweed, hellweed, devil's guts and devil's garters. The stranglehold of its stems on surrounding plants was reflected underground in a nightmare mass of thick, white roots, impossible to eradicate. And yet the artist of the Carrara Herbal expressed the plant's undeniable beauty, and convolvulus was allowed to grow over arbours both in the Islamic gardens of Spain and in 15th-century England, 'bearing its white flowers like the little church bells called sacrying bell'. The name morning glory – 'for towards night the same day that they open the flowers begin to fade' – was later transferred to their blue counterparts in America.

LEFT *The convolvulus earned a place in herbals as a purge, but a dangerous one unless small doses were carefully mixed with sweeteners and spices.*
Carrara Herbal, Italian, c.1400: Egerton MS 2020, f.33.

Corncockle and Soapwort
Agrostemma githago and *Saponaria officinalis*

CORNCOCKLE is a beautiful member of the campion family, and was once a widespread weed of cornfields (its other name, gith, meant 'weed'). It was eradicated because of the harm caused if its multitudinous black seeds were ground up with the corn, making the resulting bread too bitter to eat. Soapwort, on the other hand, was the most useful of campions with roots that create a soft cleansing lather and a disinfectant element used for skin complaints.

BELOW *Corncockle appeared often in decorative borders. In a common German name its bright centre was likened to the devil's eye, but in French and Flemish to God's eye.*
Bourdichon Hours, French, early 16th century: Add. MS 35214, f.33v.

RIGHT *Corncockle is distinguished by its long sepals.*
Circa Instans, Italian, c.1300: Egerton MS 747, f.43v.

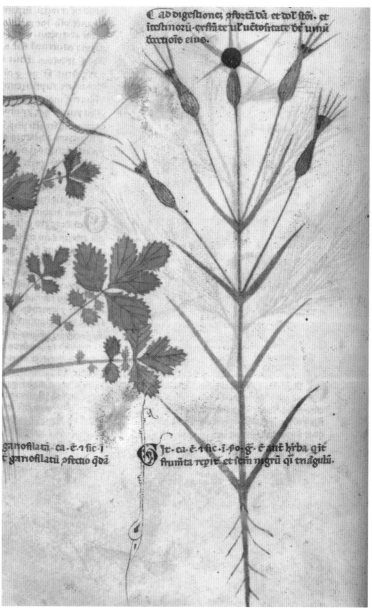

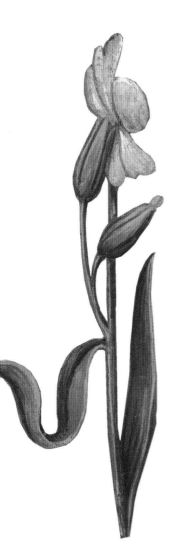

ABOVE *Old English names for Saponaria, such as bouncing bet and sweet william, suggest that, like campions and pinks, the flowers were used in flirting games.*
Bourdichon Hours, French, early 16th century: Add. MS 35214, f.88.

RIGHT *Soapwort was labelled in herbals with the equivalent Latin name Saponaria.*
Circa Instans, Italian, c.1300, Egerton MS 747, f.89r.

Cranesbill

Geranium robertianum and related species

CRANESBILL, geranium, pelargonium and erodium all relate to birds' names, describing the resemblance of the seed cases to the beaks of storks or cranes. In the 14th century Friar Henry Daniel listed a red cranesbill flower 'inch broad, wonder fair and delightable to look upon' (*Geranium sanguineum*); another 'azurish and full of great stalks' (*G. pratense*); and another 'mickle, not azurish nor full of great stalks' – which made him wonder like a true scientist 'whether diversity of soil and site maketh it grow diversely'. The cranesbill that most captured the popular fancy was herb robert (*G. robertianum*), a bold, smelly little weed with a host of names alluding to the red that suffuses the whole plant, especially the stalks. This gave it a reputation for staunching blood, and also associated it with red-faced little demons, like Robin Goodfellow or the German Knecht Ruprecht, who haunted the countryside.

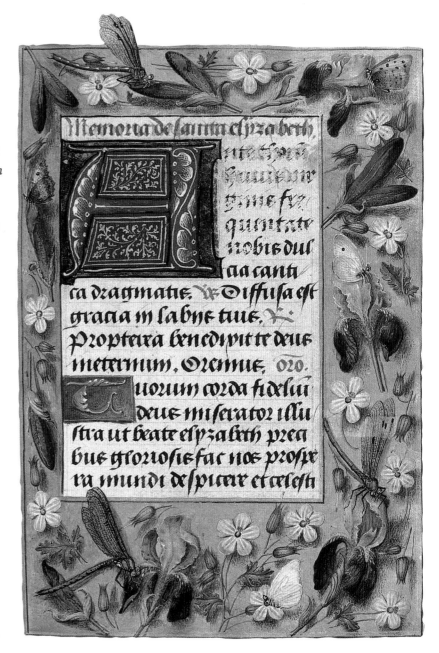

RIGHT *Herb robert was sanctified by being rededicated as* Herba Sancti Ruperti *(a little-known saint), and appeared occasionally in the borders of Ghent-Bruges Hours, alternating decoratively with blue flowers.*
Hastings Hours, Flemish, c.1480–83: Add. MS 54782, f.65.

Cyclamen

Cyclamen hederaefolium and *C. europaeum*

CYCLAMEN are native to Mediterranean countries and their name derives from the Greek *cyclos*, meaning 'circle', because as the seeds ripen, the stalks coil into a spiral the better to distribute them. This curling characteristic is echoed in the leaves and petals, and is captured in the herbal illustration here with a fine exaggerated realism. Cyclamen leaves, being shaped rather like ears, were applied for earache, and the corms were a purge – an inevitable aspect of medieval medicine. Their acrid flavour was apparently appreciated by wild boars, like truffles, and this earned cyclamen the unbeautiful name of sowbread or *pain de porceau*.

RIGHT *This herbal illustration does not necessarily prove that cyclamen were growing in England by 1300, as the text of the herbal replicated Dioscorides and Apuleius Plantonicus, and also the illustrations were copied from a European model.*
Tractatus medici de virtutibus herbarum, English, c.1300: Harley MS 1585, f.23v.

Daffodils

Narcissus pseudonarcissus and related species

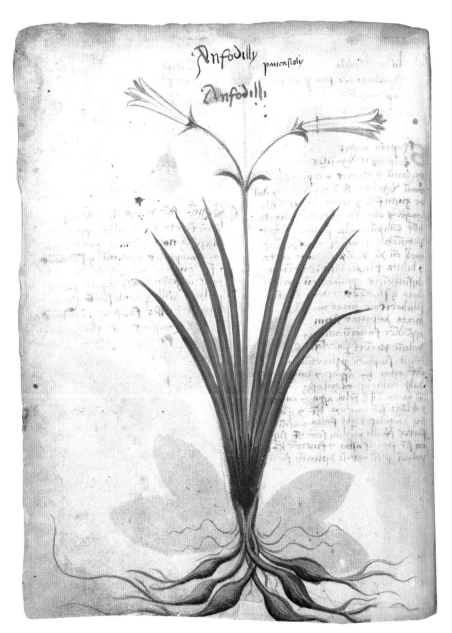

THE WORDS 'narcissus' and 'narcotic' come from the Greek *narce* meaning 'sleep, numbness, paralysis, death' because they contain a substance akin to opium – hence the foreboding tales: when Persephone plucked one flower, Hades snatched her to the Underworld; Narcissus, besotted with his own reflection in a pool, was transformed into this plant. Asphodels (*Asphodelus albus*) grew on the banks of Lethe, the river of oblivion, and also in the Elysian Fields, where the spirits of heroes languished in a perpetual twilight. Medieval scholars and poets, including Dante, kept these stories alive by describing the earthly paradise and recalling that Persephone, like her lovely flowers, returned to life each spring rejoicing.

LEFT *In the ancient and medieval world daffodils and asphodels were grouped together, and the label* afodilli *could apply to either. In this herbal it was also applied to the day lily* Hemerocallis flava. Belluno Herbal, Italian, early 15th century: Add. MS 41623, f.64v.

ABOVE *Narcissi seldom appeared in paintings; when they did, as in Leonardo da Vinci's* Virgin of the Rocks, *their classical associations were transferred to a Christian context.* Bourdichon Hours, French, early 16th century: Add. MS 35214, f.15.

Daisies
Bellis perennis and related species

CHAUCER joked that daisy meant 'eye of day' and claimed it as his favourite flower, growing 'white and rede' in the flowery mead. The Latin name *bellis*, meaning 'war', reflects the plant's value as an instant healing herb on the battlefield. There was also a connection with virginity, inherited from the ancient world. *Parthenium*, the Latin name for the daisy-like feverfew, meant 'virgin' (as in Parthenon, the temple of the war-like virgin goddess Athene). Moon daisies were dedicated to Artemis, the other fierce, arrow-wielding goddess who protected women. Their attributes were inherited by doughty virgin saints, such as St Margaret the dragon-slayer, after whom marguerites were named. Daisies became the emblems of powerful women (not always virgins), including Margaret Beaufort, mother of Henry VII. The link between daisies and the Virgin herself in her protective role was therefore derivative but strong.

ABOVE *In the Ghent-Bruges Hours, daisies appeared single and double and in variations of pink, white and red.* Huth Hours, Flemish, c.1480–85: Add. MS 38126 f.42v.

RIGHT *Marguerite or ox-eye daisy, (Leucanthemum vulgare).* Bourdichon Hours, French, early 16th century: Add. MS 35214, f.41v.

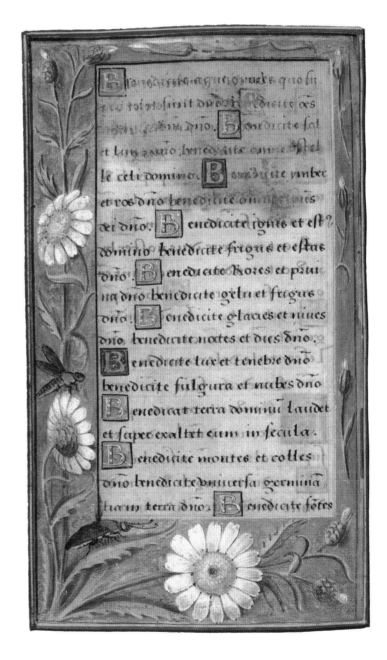

Dill and Coriander

Anethum graveolens and related species

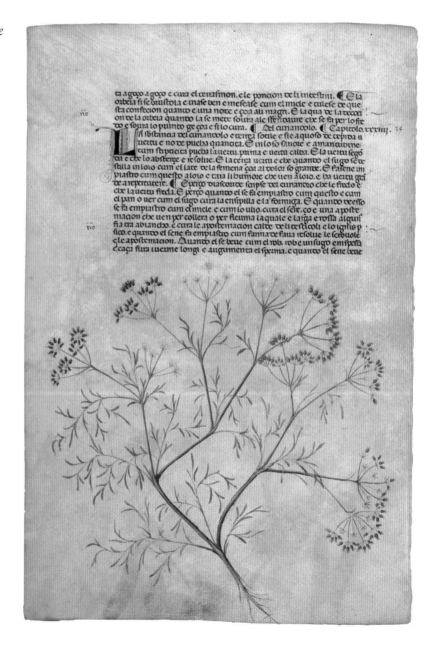

PLANTS of the *Umbelliferae* family have flowerheads massed with tiny florets; whitish or yellowish, but with peculiar grace, they range from carrots, parsnips and parsley to hemlock. In the Middle Ages the most important were dill and fennel, which share soothing medicinal qualities, especially for colic. Dill, coriander and ground elder were Roman introductions, all for pain relief; and even hemlock, most famous for its role in poisoning Socrates, was an anti-spasmodic drug, used for epilepsy, hydrophobia (rabies) and as an antidote to other poisons.

ABOVE *Dill was indistinguishable in early herbals from fennel, but for the name* Anetum *(fennel,* Foeniculum vulgare, *was named* Feniculum*); but the diagramatic illustrations captured their charm.*
Tractatus medici de virtutibus herbarum, *English c.1300: Harley MS 1585, f.54v.*

RIGHT *Coriander,* Coriandrum sativum, *took its name from the Greek* koros *(bug), because the plant smells like squashed bugs.*
Carrara Herbal, Italian, *c.1400, Egerton MS 2020, f.26v.*

Elecampane
Inula helenium and related species

IN THE plays of the mummers, the Doctor used a potion called 'hell-and-come-pain', in his comic and ultimately successful attempt to revive the dead combatants. This potion was elecampane, named after Helen of Troy (whose powers included healing), and containing a medicinal agent now called helenin. Elecampane was cultivated all over Europe and is still most likely to be found on old monastic sites. Coltsfoot (*Tussilago farfara*), much smaller but with similar properties, was graced with this onomatopoeic Latin name, meaning 'cough', and was recommended as a leaf tobacco that was smoked through a reed pipe to relieve lung problems, especially asthma. A third yellow daisy, which was burnt to form a cloud of smoke, was fleabane (*Inula dysenterica*), for repelling biting insects.

RIGHT *Elecampane (left) derived from an earlier Latin name,* Inula campana; *it was also reputed to be the flower Helen was picking when Paris abducted her.*
Circa Instans, Italian, *c.*1300, Egerton MS 747, f.34v.

Euphorbia

Euphorbia lathyrus and *E. helioscopia*

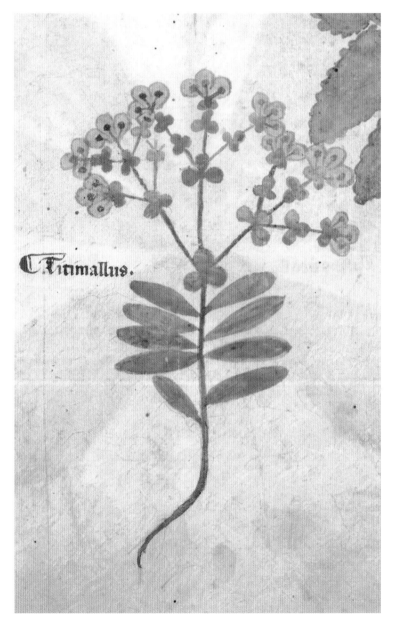

IN CHAUCER'S *Nun's Priest's Tale*, the splendid cockerel Chanticleer nearly fell off his perch with a terrible dream portending his capture by a fox. His favourite hen, Pertelote, dismissed the dream as a sick fancy and recommended a purge for his melancholy humours. The mix included catapuce, meaning euphorbia, but Chanticleer dismissed it as 'venomous, I know it well'. It was characteristic of Chaucer to take a swipe at contemporary medicine, amusing all who shared his scepticism about the virtues of emetic plants. Other dubious uses included substituting euphorbias for capers (since the seed-cases look alike), and squeezing their milky latex onto warts.

ABOVE *The caper spurge,* E. lathyrus, *known to Chaucer's contemporaries as catapuce and labelled* Cataputia *in this herbal.* Circa Instans, *Italian, c.1300: Egerton MS 747, f. 25v.*

RIGHT E. helioscopia, *sun spurge, an example of the liveliness of some herbal illustrations.* Circa Instans, *Italian, c.1300: Egerton MS 747, f. 101.*

Figs

Ficus carica

IF FIGS were not the forbidden fruit of Eden, they were certainly regarded as part of the curse, their leaves hiding the shame suddenly felt by Adam and Eve in the sight of God. Fig leaves became forever linked with genitalia, and the opened fruits with female organs. Memorably, Christ cursed a fig tree; and perhaps there lingered a folk memory of Dionysiac revels, which included a gigantic phallus carved from fig wood. Naturally the succulent fig remained a widespread fruit tree in southern Europe and the Holy Land, but there were few claims that figs were cultivated in medieval England, although one was incongruously attached to that sternest of saints, Thomas Becket.

RIGHT *A moral instruction book written for the younger members of a Genoese family, here shown together in their garden in the shade of figs (left) and other fruit trees, including pomegranates (right).*
Cocharelli Treatise on Vices, Italian, late 14th century: Egerton MS 3781, f.1.

Forget-me-nots and Speedwells
Myosotis sylvatica and *Veronica chamaedrys*

IN MEDIEVAL Europe, the little blue flowers of both forget-me-nots and speedwells signified remembrance, their interchangeable names being *ne m'oubliez mye* and *vergiz mein nicht*. In tournaments, with their aura of romance, the victor's collar was worked with either of these blue flowers, and the name 'speedwell' may derive from this custom, like another old German name for the plant, meaning 'prize of honour'. Around 1390, Henry of Lancaster, later Henry IV, who spent his years abroad jousting, took for his emblem a blue flower called *souveigne vous de moy* (remember me). As king he continued to use the emblem, linked with the letter S, which stood either for 'souvenir' or 'sovereign'. In 15th-century Germany, forget-me-nots became fashionable in the posies that were held in portraits, and gradually speedwells lost their share of meaning.

ABOVE AND RIGHT *The illuminators of Ghent-Bruges manuscripts observed the differences between five-petalled forget-me-nots (above) and four-petalled speedwell (above peacock, lower right), and the subtler tiny marks on the plants that only the most skilled of brushstrokes could capture. Note also the stylised swirling silver acanthus leaves decorating the margins.*
Isabella Breviary, Flemish, 1497: Add. MS 18851, f.164.

Foxgloves

Digitalis purpurea and *Digitalis grandiflora*

PERHAPS foxglove should be folksgleow, 'folks' referring to fairyfolk, and 'gleow' meaning a row or chime of little bells. All animals, including foxes and rabbits, avoid these flowers, and in Celtic folklore they had magical properties. When the beauty of a woman's cheeks was compared to foxgloves (not roses) she was an enchantress. Medieval physicians also avoided foxgloves, except to treat scrofula, and there was no knowledge of their importance in treating heart failure until late in the 18th century.

ABOVE *With Bourdichon the soft yellow* Digitalis grandiflora *made its first appearance in manuscripts, again displaying the increasing interest in flower variation.*
Bourdichon Hours, French, early 16th century: Add. MS 18855, f.21.

RIGHT *Foxgloves are not poisonous to bees, but designed entirely to attract them and other insects, as seen here.*
Bourdichon Hours, French, early 16th century: Add. MS 18855, f.107.

Garlic

Allium sativum and related species

GARLIC and all related alliums, from onions and leeks to ornamental flowers, contain an essential oil rich in sulphur, hence their intense smell. This was believed to ward off the powers of evil (or even, if fastened to a horse's bridle, to help win a race). Beyond doubt, garlic has powerful antiseptic qualities and is one of nature's best substitutes for an antibiotic. Different alliums grew throughout the ancient world. The wild garlics of England have white star-like flowers and were called ramsons. But the smell was always a problem and Chaucer's Summoner, who reeked of garlic, was one of his most unpleasant characters.

LEFT *Bourdichon painted garlic and several other alliums, emphasising their decorative qualities.* Bourdichon Hours, French, early 16th century: Add. MS 35214, f.107.

ABOVE *In herbals, garlic was valued for its antiseptic powers.* Circa Instans, Italian, c.1300, Egerton MS 747, f.50v.

Gourds, Cucumbers and Melons

Lagenaria vulgaris, Cucumis sativus and *C. melo*

IN HIS 9th-century poem on gardening, the German monk Walafried Strabo wrote 'when a melon is cut it throws out gushing streams of juice and many seeds'. Like gourds and cucumbers, melons retained the fascination of their eastern origins, enhanced by biblical allusions. When the Israelites followed Moses into the desert, they yearned for the cucumbers and melons of Egypt. When Jonah survived the belly of the whale and sat outside Nineveh waiting for its destruction, a gourd grew up to shelter him. Even in southern Europe their cultivation involved much nurturing on fermenting compost heaps (although Edward III is reputed to have had cucumbers grown for him); and gourds belonged to pilgrims who returned from hotter climes with exotic water flasks.

ABOVE *Melon's Latin name means sweet (*melo*) cucumber (*cucumis*).* Carrara Herbal, Italian, *c.*1400: Egerton MS 2020, f.163.

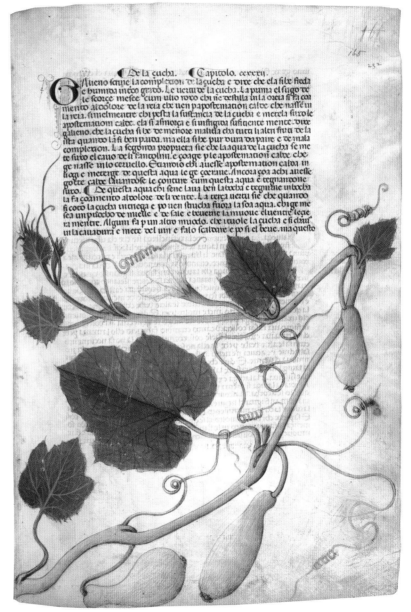

RIGHT *The Latin name for the common gourd comes from* lagena *(flask) and* vulgaris *(common).* Carrara Herbal, Italian, *c.*1400: Egerton MS 2020, f.165.

Hawthorn

Crataegus monogyna

JOYOUS lords and ladies fetching may branches to decorate love arbours and maypoles knew the story of King Arthur's Guinevere, who went a-maying all dressed in green; she was the very symbol of seduction and abduction. Humbler folk also gathered the may or hawthorn blossom, and moralists ranted against the licentious behaviour accompanying these excursions. The Church gave hawthorn a new symbolism as the crown of thorns with which Christ was tormented and crucified. To all occasions the hawthorn lent its curious scent, trimethylamine, which is present in the smell of sex and putrefaction.

OPPOSITE *A scene of fetching may blossom. The calendar pages of Books of Hours were often illustrated with the occupations of the months.* Golf Book, Flemish, early 16th century: Add. MS 24098, f.22v.

RIGHT *May flowers in blossom. The plant's other common names, such as maythorn, quickthorn and hawthorn, allude to its thorns (seen here) and dark little fruits, known as haws.* Bourdichon Hours, French, early 16th century: Add. MS 18855, f.67.

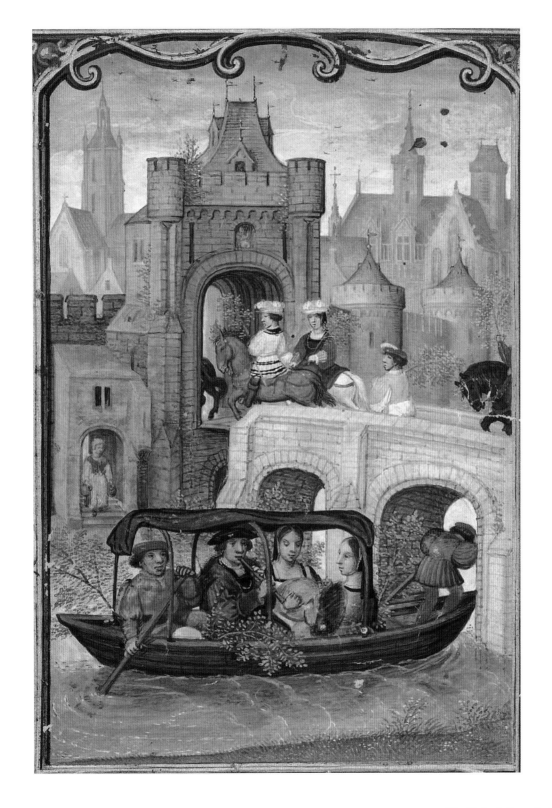

Hellebores

Helleborus viridis and related species

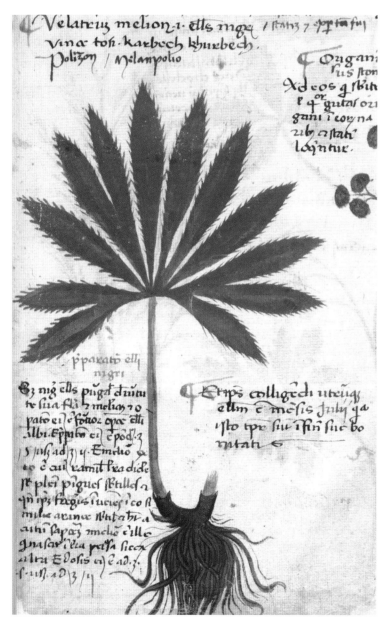

HELLEBORES, being narcotic, were believed to calm the deranged. A Greek shepherd, Melampus, discovered a way of feeding hellebore to his goats and diluting the cure in their milk, otherwise it would have killed the afflicted. In the Middle Ages hellebore was still used on sick livestock, threaded into ears or dewlaps (skin flaps) to drain away infections. The Greeks used their native white-flowered hellebore (*H. niger*), but in Europe the green-flowered species (*H. viridis* and *H. foetidus*) were better known. All have black roots and all were known as *niger*. Friar Henry Daniel, when describing his London garden, explained: 'Hellebore with the white flowers flowereth in cold winter. That other, the black, hath flowers deep swart green, and flowereth when the sun is in Aquarius.'

LEFT *The root that caused hellebores to be labelled black, or in this case* nigri.
Belluno Herbal, Italian, early 15th century: Add. MS 41623, f.3.

OPPOSITE *The green flower of* Helleborus viridis, *here labelled* Elebor negro. *Apart from being illustrated in herbals, the only other appearance of a hellebore was in Botticelli's* Primavera *(c. 1482).*
Belluno Herbal, Italian, early 15th century: Add. MS 41623, f.100.

ꝓreis agitte 7 ista lactinde uocat at puisat hystas hit 7 chubiti longitudicz ꝑ manus
7 histitudicz cubiti uni 7 ꝗ 7 onctu rerudu folia tasta ꝗ ob long sem 7 7 enenimicz
agitu dulce radix ꝯ tutt grana accepta at uini sicut catapucia comesta 7 suꝑ enta
añ accepta flu 7 coloras deponut siue ex eo fact sicut de titinnall oia supion fa
ecre potuit folia ei cu galina aut cu uitello accepta uentrez solut.

Iste ꝯ Ellebor niger ꝗ incipiut apire de mese marcij 7 ꝑ mese

Elebor Negro

De mese madij
lactinde uochat

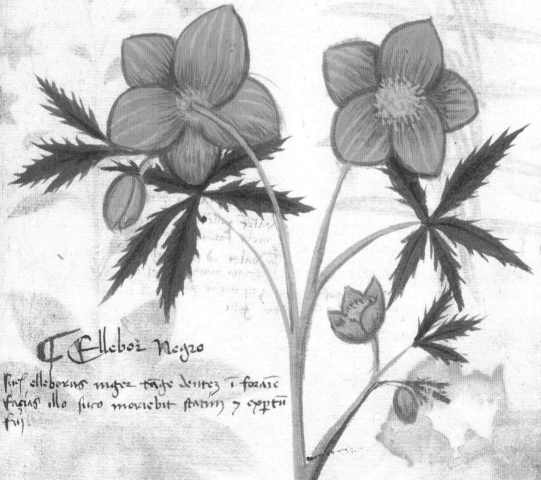

Ellebor Negro

siue elleborus niger tange dentez 7 forare
facias illo suco mouebit statim 7 exptu
fu.

Hollyhocks and Mallows

Althaea rosea, Malva sylvestris and related species

ORIGINALLY an Asian flower, the hollyhock reached the Islamic gardens of Spain by the 11th century. It was apparently Edward I's queen, Eleanor of Castile, who introduced hollyhocks to England, either from Spain or the Holy Land. An English name for the plant, 'outlandish rose', recalls the French *rose d'outremer* (meaning 'overseas', where crusades were fought) which, like 'holy hoc', suggests that hollyhocks came from the Holy Land. But Friar Henry Daniel called the plant *rosa hispanica*, rose of Spain, and claimed that the common mallow was known as 'holyoc'. Herbalists appreciated the soothing mucilage of mallow, which is also the source of marshmallow sweets.

ABOVE Althaea *comes from the Greek for 'cure', while the family name* Malva *comes from the Greek for 'soft', combining hollyhock's salient features.*
Bourdichon Hours, French, early 16th century: Add. MS 35214, f.122v.

RIGHT *Enchanted by the way the edible seeds of mallow are packed into little circular cases, like cheeses, the Dutch called them* keeskens cruyt.
Bourdichon Hours, French, early 16th century: Add. MS 35214, f.101.

Honeysuckle
Lonicera caprifolium

HONEYSUCKLE was a favourite for training over arbours, and its heady evening scent was associated with romantic assignations. In the early 15th century, the English poet John Lydgate wrote in *The Troy Book*:

> And honeysuckles among the
> bushes green
> Embalmed had environ all the air

Other, less romantic, European names testified to the partiality goats had for its leaves: *chevre-feuille*, *geissblatt* and *capri-foglio* (all meaning 'goat-leaf'). *Lonicera caprifolium* was the honeysuckle native to southern Europe, while *L. periclymenum* was more familiar in northern Europe.

RIGHT *Honeysuckle found its way into herbals as a treatment for spleen, convulsions and freckles.*
Belluno Herbal, Italian, early 15th century: Add. MS 41623, f.16.

Hops
Humulus lupulus

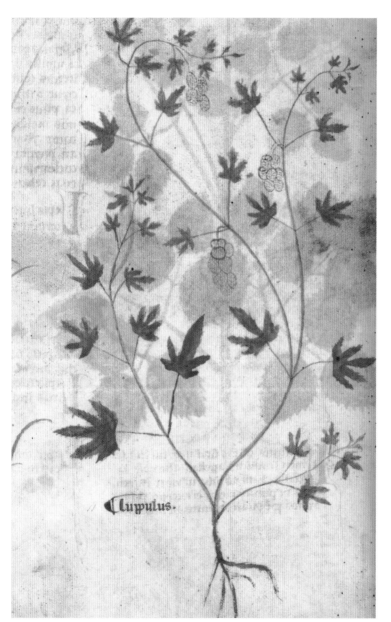

Clupulus.

IN 1426 an innkeeper in Kent was prosecuted for 'putting into beer an unwholesome weed called a hoppe', and for 100 years the legislation continued because hops (rather than alcohol) were believed to incite disorder among the masses. For instance, in 1450, hops were blamed for fuelling Jack Cade's rebellion and the 'complaint of the commons of Kent' against the inept government of Henry VI. In Europe the importance of hops for clarifying, flavouring and preserving beer had long been appreciated, and hops were an important crop in the Flemish territories of the dukes of Burgundy. However, hop-gardens were initially established to nurture the young shoots, which were eaten as a delicacy, like asparagus. The first recorded hop-garden was that given by Pepin, the father of Charlemagne, as a gift to the Abbey of St Denis outside Paris in 768.

LEFT *In herbals, hops were valued for their calming, sedative powers.*
Circa Instans, Italian, c.1300: Egerton MS *747, f.55v.*

ABOVE *The chivalric Order of the Hop was founded by John the Fearless, Duke of Burgundy, who had the frontispiece of his* Livre de Merveilles *(1413) decorated with hops.*
Bourdichon Hours, French, early 16th century: Add. MS 35214, f.106.

Houseleeks
Sempervivum tectorum

FROM THEOPHRASTUS, who in *c*.300 BC described houseleek '[growing] upon roof tiles', to the Norse name *taglog*, meaning 'roof plant', there was widespread evidence that the potential of *Sempervivums* to resist all weathers was exploited as a building material. Their ability, not only to survive but to throw out endless pink rooting stems, with curious cobwebby filaments resembling venerable beards among the rosettes of leaves, led to names inspired by the gods of storm and thunder – Jove or Thor. These included *Jovisbarba*, *joubarbe* and *donnerbart* (thunder beard). And if houseleeks could protect against fire and lightning – it took just a leap of sympathetic imagination for them to be used in cooling ointments for burns and inflammations.

RIGHT *The characteristics and protective functions of houseleeks are here graphically captured by the roofs and lightning sketched in the background. Leek is an old word meaning 'plant' and houseleek is also a time-honoured name.*

Circa Instans, Italian, *c*.1300: Egerton MS 747, f.88v.

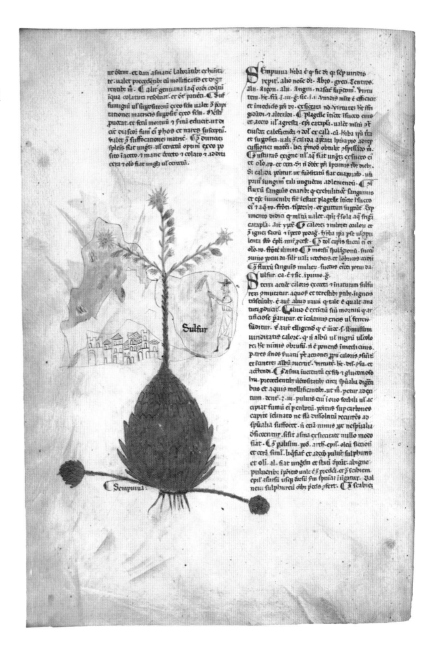

Hyssop and Marjoram
Hyssopus officinalis and *Origanum vulgare*

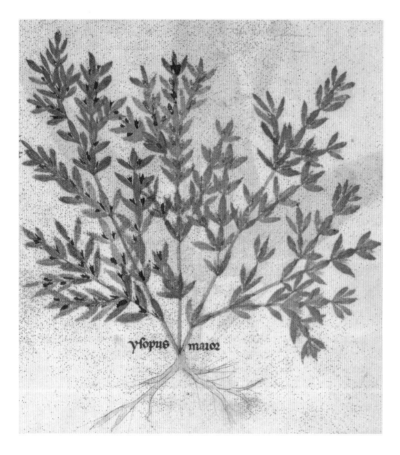

THE TEXT OF PSALM 51, 'Purge me with hyssop and I shall be clean', arose from a confusion between the Hebrew word *ezob*, a cleansing herb used in religious rituals, and the Greek *hyssopos*, meaning the blue-flowered herb which grows in Europe, but not in the Holy Land. The biblical *ezob* was marjoram, native throughout, and with a medical reputation far greater than hyssop. The purifying ritual for which it was invoked included sprinkling with holy water. The action began with a prayer repeated in every Book of Hours, opening with *Asperges me…* (Thou shalt sprinkle me…), and the sprinkler continued to be called a hyssop even when it was made of metal. Marjoram flowerheads (unlike hyssop) do retain water droplets, which would also explain the use of *ezob* to moisten the lips of Christ on the Cross (John 19).

ABOVE *Hyssop was considered medicinal, but was primarily used as an ingredient in liqueurs like chartreuse.*
Circa Instans, Italian, *c.*1300: Egerton MS 747, f.48.

OPPOSITE *Various species of oregano or marjoram are native throughout Europe and the Middle East, all producing essential oils with great medicinal efficacy.*
Circa Instans, Italian, *c.*1300: Egerton MS 747, f.70.

lübricos necat. Emplm ex oppopanace
ualet et cotusies lacertorū.

Opium fit. e. i. iii. g. sic ipio
opium aliud e thebaicū. q. ita diaf.
q. ibi precipue sit. ul. in ulemanis pblic
nascentis. aliud tranensius. q. a sa secũd
bi. ul. la sur dcquo dictū est. opiū sic fit
insestate tpe maturitatis precipue opa
tur. scapitibz papauens albi et folis qs
dam incisiones cũ cultello. et lac eman
nans circa capi innegat. et abradatur cũ
cultello. et manibz steris. h opiū the
baicum dr et opiuz tranese. q. trane i
ciuitate in pulie sit. s. tñ nõ ualet. e
ergo elligendū opiū thebaicū. q. est
ualoz curibile. nec multū duruz. nec
milius molle. opiū thebaï cũ durus est
opiū tranese mollius est. duruz sua
tur p. xx. annos. i etiā utz cũ picitur. in
medicinis ponitur ut reprimatur uirtu
tes sper acutaruz. Un ille medicie dr
opiate. Uirtutes he cstrigendi. et morti
ficandi. si medicis calidis nõ psegtur
suus effectus. ppe cdictiones tpiz cali
daruz. Uirtutes he encoticaz. i. sõpnise
ram. Et sõpniz puccandū fiat em
plastrū ex apio resoluto i lacte mulieri
addito pliiere madragoze. Ed aptata
cala. ut cerpre estomenuz. pficiat cũ
pliie congiol. ul. yqam. et siar eplm
ex opio psecto cũ lacte mulieris i olei
cet. tñ tuc tolor minuat. locus mortifi
cando pls tñ nocet. qz materiā psuat

Origanū ca. e. i sic. i. iii. g.
alio noie Solena dr. cuius duplex
e maneries. s. origanuz siluest. qd latioza
he folia. et fortius opaf. aliud est doni
sticus. q. cutis reptili. minuta hñs so
ba. et suauis opatur. h tmedicias e pri
duz. colligit aut ipsa floz. i stloribus
mulbez suspeditur. et essicatur folia i
floriz abietis stupitis in medicis obr
poi. suatur pãu. singul annis reno
uetur. Uirtutez he dis i acuta. relaxa dis
i psistendi. Es suu reuz folia cũ floriz
i testa suu liquore cassea i saccello poni f.
et capiti suppatur saccellus. cap etiā
bñ coputatur ut sudet. Uinuz dctis
onis eius gargariatur ginguaruz i sau
truz psuant huitate. Epuluis eius

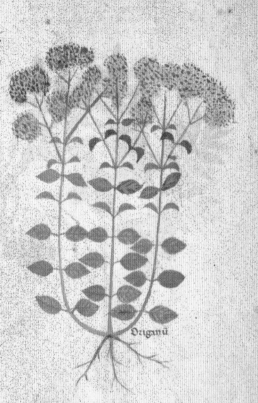

Origanū

uulne suppositi hũores psuit. Es as
ma suiz detur uinũ dctiois eius et
sicuuz sicrani et puluis eius cũ mel
le pfectus dr. ut i duir cũ acuta.
Uinuz dctioie ei digestiones psor
tat. ul stoi i teestoz excludit. Es
siculi formati ex sila cata i uino psup
posita remibz. stm. i dis. soluit. Es st
nasino ex sra. ca. cũ aybue añ e crta
pului ei stirpe suposit ano suponatur
siba ipa iuino i olo dctta i uulue cũ
taplata duricies eius soluit. E some

Irises

Iris germanica and *I. pseudacorus*

THE ROYAL flower of France started as a yellow iris. Clovis, a 6th-century king of the Franks, escaped his enemies to gain the advantage because he saw irises – characteristically growing where a river was shallow – and his army forded it, turning defeat to victory. During the crusades Louis VII revived the emblem and the flower was renamed *fleur-de-Louis*, hence *fleur-de-lys*. After 1340, as part of their claim to the French throne, the English royal arms also included the *fleur-de-lys*. Heraldically, the iris remained golden, but in cultivation the purple flower was preferred, and purple was also a royal colour. In Christian art irises became associated with the heavenly royalty of Christ, supplemented by the classical concept of iris as the rainbow, the messenger of heaven on Earth.

RIGHT Iris pseudacorus. *The sword-like leaves gave rise to further names, such as sword lily, and like the gladiolus or gladdon, they were linked with the sword that, metaphorically, pierced Mary's heart at the Crucifixion.*
Bourdichon Hours, French, early 16th century: Add. MS 18855, f.94v.

OPPOSITE Iris germanica. *The iris was also an emblem of Florence, which was the centre of production for perfumes derived from orris (iris) root.*
Bourdichon Hours, French, early 16th century: Add. MS 18855, f.33.

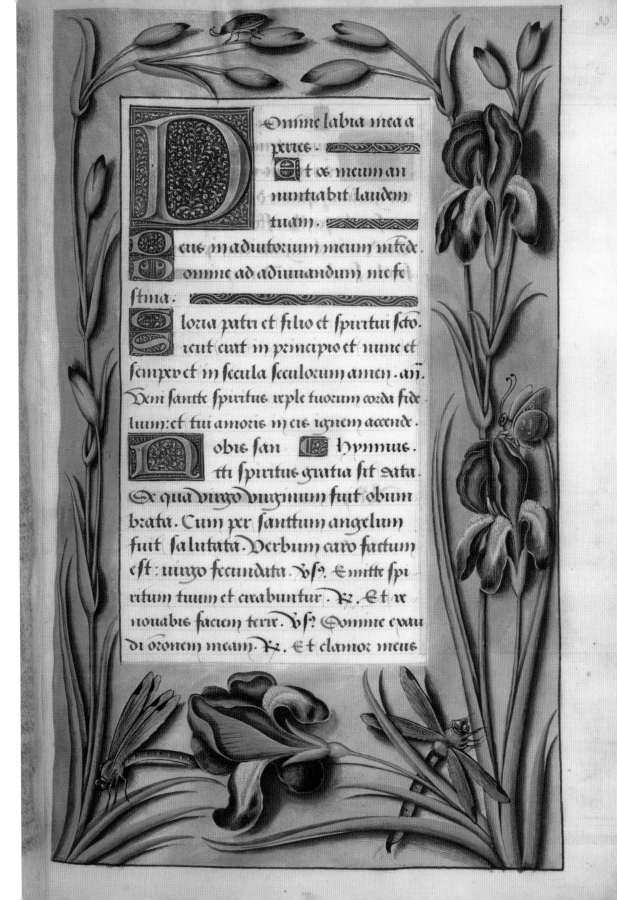

Omine labia mea a
peries.
Et os meum an
nuntiabit laudem
tuam.
Deus in adiutorium meum intede.
omine ad adiuuandum me fe
stina.
loria patri et filio et spiritui scto.
icut erat in principio et nunc et
semper et in secula seculorum amen. an.
Uem sancte spiritus reple tuorum corda fide
lium: et tui amoris in eis ignem accende.
Nobis san Hymnus.
cti spiritus gratia sit data.
De qua virgo virginum fuit obum
brata. Cum per sanctum angelum
fuit salutata. Verbum caro factum
est: virgo fecundata. Vs. Emitte spi
ritum tuum et crabuntur. R. Et re
nouabis faciem terre. Vs. Domine exau
di orationem meam. R. Et clamor meus

Ivy and Bay
Hedera helix and *Laurus nobilis*

ABOVE *Bay is the English name for true laurel. The Middle Ages inherited the Greek myths that bay and daphne were sacred to Apollo and were used by the priestesses of his oracle at Delphi. Myrtle was sacred to Venus and the evergreen holm oak to Zeus.*
Circa Instans, Italian, c.1300: Egerton MS 747, f.40v.

OPPOSITE *An ivy bush was the medieval sign for an inn. The sense of competition with the vine was retained in the saying 'good wine needs no bush', and in the belief that ivy counteracted the effects of alcohol.*
Circa Instans, Italian, c.1300: Egerton MS 747, f.37.

EVERGREEN plants were endowed with an aura of immortality suitable for religious festivals. The Jewish Feast of Tabernacles and the Roman Saturnalia both offered precedents for constructing leafy shrines for sacred rites, which the Christian Church reluctantly transferred to the calendar for Christmas with the words *templa ornantur* (let the temple be decorated). In northern Europe holly and ivy retained, in certain carols, a pre-Christian sense of a ritual contest between light and dark. In the south ivy was associated with vines – both equally sacred to Bacchus, the Roman god of wine: 'ivy his winter crown, the vine his crown in summer' – and in medieval manuscripts tiny gilded ivy leaves decorated the borders alongside vine tendrils. Another survival was the idea of triumphal crowning with garlands of evergreen leaves. For victors in war this was palm; for poets either ivy or laurel (meaning bay); but originally it was religious celebrants who wore leaves. All of which may help to explain why carving leaves into the fabric of churches was adopted everywhere with enthusiasm.

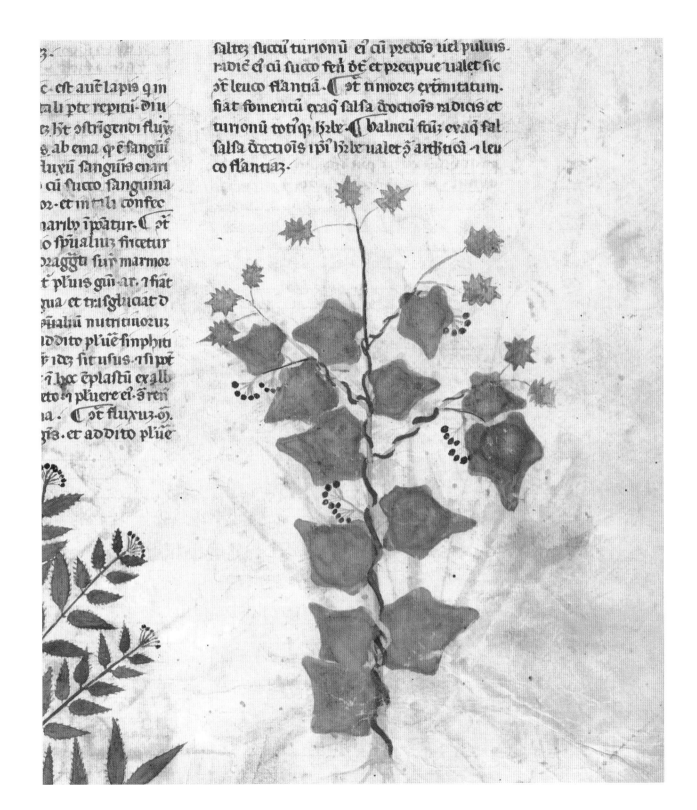

Jasmine
Jasminum officinale

JASMINE originated from China, where it was named *yeh-hsi-ming*. Its perfumed oils, reaching Persia, were mentioned by Dioscorides, and continued, under the Arabic name *sambac*, to be traded along the silk routes and into Europe. In the Islamic gardens of 11th-century Spain 'all sorts of jasmine were found' – meaning *Jasminum grandiflorum* and *J. sambac*, which were larger flowered with heavier perfume – and *J. officinale*, the only jasmine that grew readily in Europe and the only one illustrated in medieval herbals; although sometimes the name *sambac* was hopefully attached to it. In 1348 the Italian poet Giovanni Boccaccio described jasmine perfuming the walks of a garden outside Florence, but its first appearance in France was in *Anne of Brittany's Hours*.

RIGHT *In the Middle Ages, jasmine was known only in southern Europe through connections with the Arab world.*
Circa Instans, Italian, *c.*1300: Egerton MS 747, f.98.

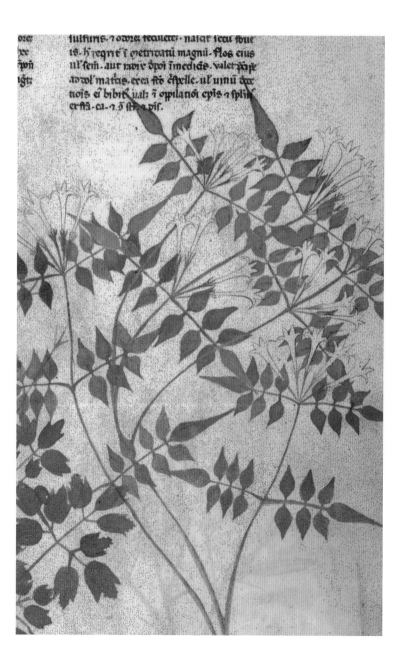

Larkspur and Monkshood
Delphinium consolida and *Aconitum napellus*

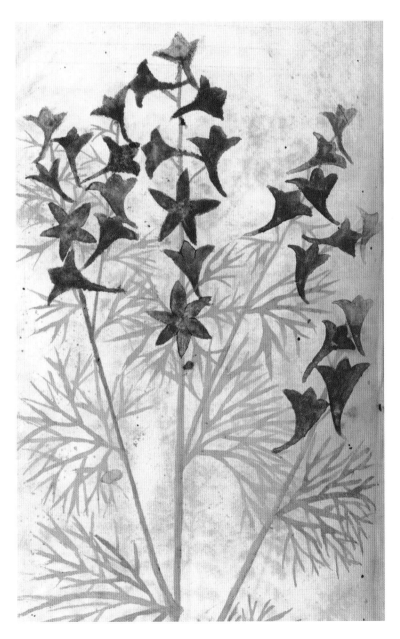

LARKSPURS are the wild delphiniums of Europe. Their Latin name, *Delphinium* signifies dolphins because of a heraldic twist in the buds that resembles a swimming fish. The sign of Pisces, the fish, was also described as looking like a dolphin in star charts: 'a bending shape by which sign also the heavenly dolphin is set forth'. The finest manuscript appearance of larkspur was in the *Tres Riches Heures du Duc de Berry* (*c.*1415), in the margin beside Christ's miracle of feeding the five thousand with loaves and fishes, where the flowerbuds look very like fish. In herbals the closely related monkshood was more familiar, deadly in a poisoner's hands, but used externally for liniments.

LEFT *The larkspur of southern Europe,* Delphinium staphisagria, *known as stavesacre or lousewort, appeared in herbals for use against vermin.*
Circa Instans, Italian, *c.*1300: Egerton MS 747, f.108v.

Lavender

Lavandula angustifolia and *L. stoechas*

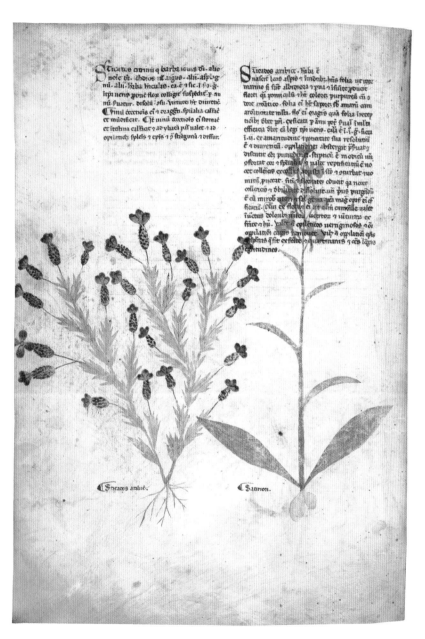

LAVENDER, named after the Latin for 'washing', was established across Europe by the Roman passion for scented baths. During the cold, lawless centuries that followed, lavender was seldom recorded, except as a favourite in the Islamic gardens of Spain. In herbals stickadove (*L. stoechas*) was considered more efficacious for headaches and nerves but, being less hardy, was not grown in northern Europe. A third type, spike lavender (*L. spica*), yielded spike oil, sometimes confused with spikenard (*Nardostachys grandiflora*), a fabulously expensive perfume from an Indian plant. Mary Magdalene possibly anointed Christ with real spikenard, certainly the cost annoyed the Pharisees, and the pot of ointment became her symbol. To the medieval imagination it probably wafted the scent of lavender.

FAR LEFT *Stickadove (L. stoechas) derived from Stoechades – the islands off the coast of Marseilles (now the Iles de Hyères), where it grew in abundance and was known as French lavender.* Circa Instans, Italian, *c.*1300. Egerton MS 747, f.89v.

ABOVE *Lavender (L. angustifolia) lined the garden walks of the Hotel St Pol in Paris, designed for Charles V of France in c.1370.* Huth Hours, Flemish, *c.*1480–5: Add. MS 38126, f.27.

Lettuce and Dandelion

Lactuca sativa and *Taraxacum officinale*

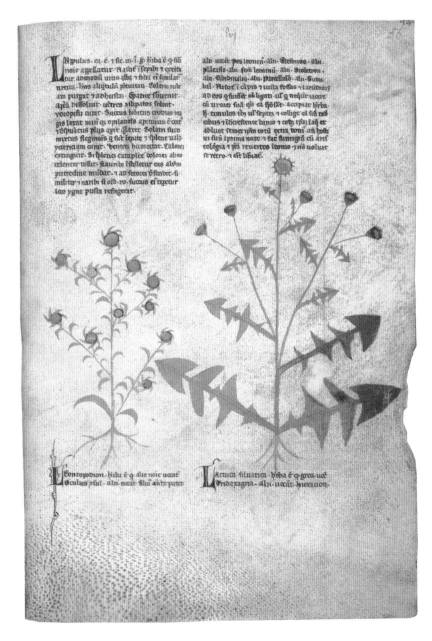

WILD lettuces were cone-shaped plants, with a taste that placed them among the bitter herbs of the Jewish Passover. But the Romans developed them into leaves they could relish; and the white latex exuded by their stems, judged in ancient Egypt to resemble semen, was likened instead to milk and named *lactuca*. It is faintly narcotic. Galen recommended lettuce for a soothing evening meal, and the latex was dried into a brown painkiller called *lactucarium*. Dandelions were also called *lactuca*. As their latex is diuretic, it was used in liver and kidney complaints. Throughout Europe, their jagged leaves led to names like *dent-de-lion* (lion's tooth), recalling the champing profile of a heraldic lion.

ABOVE *The medicinal value of dandelions, and probably the link with lions, derived from Arabic texts.*
Tractatus medici de virtutibus herbarum, English, c.1300: Harley MS 1585, f.52.

FAR RIGHT *Lettuce was thought to dull the senses, hence Cleopatra's 'salad days, when I was green in judgement, cold in blood'. But did Shakespeare also know that in Egypt lettuces were associated with sexuality?*
Circa Instans, Italian, c.1300: Egerton MS 747, f.56.

Lilies

Lilium candidum, L. bulbiferum and *L. martagon*

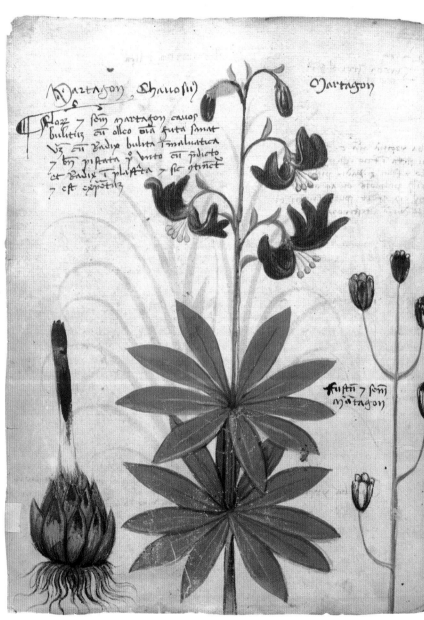

NO MEDIEVAL garden was complete without white lilies (*Lilium. candidum*); nor any picture of the Annunciation once Duccio, the 13th-century Sienese painter, had introduced their use. His contemporary, Bartholomeus Anglicus, explained their mystic appeal: 'though the petals be white yet within shineth the likeness of gold' – a symbol of supernatural purity that was already centuries old. Although they look exotic, lilies grew wild in eastern Europe, and were distributed by the Roman legions as a cure for wounds, boils and bunions. Orange lilies

(*L. bulbiferum*) have the same provenance, but until the 15th century they were ignored, being considered inferior. Martagon lilies remained rare because they dislike cultivation, unless it replicates their natural habitat exactly.

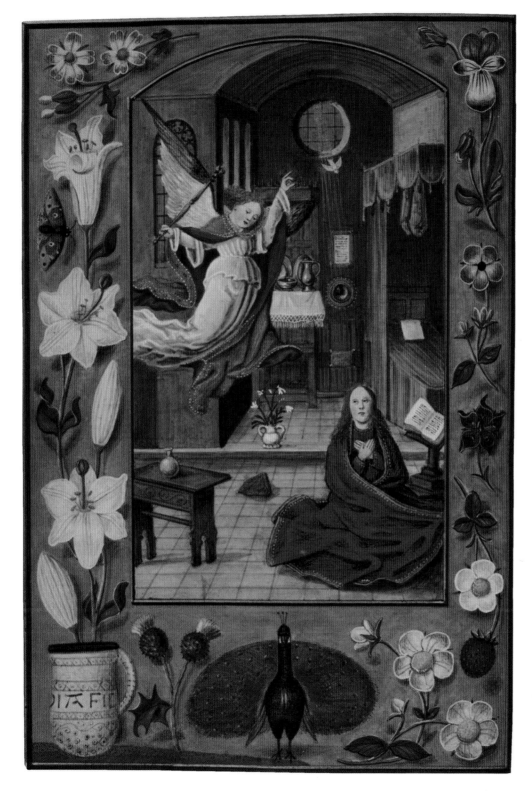

LEFT *White lilies were above all associated with the Annunciation (by the angel to the Virgin Mary). In this Book of Hours, they appear in the centre of the miniature and in the vase in the border.*
Egmont Hours, Flemish, Add. MS 35319, f.45v.

OPPOSITE TOP *The white lily became known as the Madonna lily in Victorian times, but its link with the Virgin can be traced to the Venerable Bede, c. 700.*
Hastings Hours, Flemish, Add. MS 54782, f.265v.

OPPOSITE LEFT **Lilium bulbiferum** *occasionally appeared in 15th-century religious paintings and manuscripts, probably symbolising Christ's sacrificial blood, since their colour deepens to red.*
Bourdichon Hours, French, early 16th century: Add. MS 35214, f.39.

OPPOSITE RIGHT
Martagon lily, one of the finest examples in this herbal of local flowers studied from life.
Belluno Herbal, Italian, early 15th century: Add. MS 41623, f.66v.

Lily of the valley and Solomon's seal
Convallaria majalis and Polygonatum multiflorum

BOTH plants, on account of their upward-tilting leaves, were called ladder of heaven, *scala caeli*, which in English was reduced to 'scalacely'. Lily of the valley (wrongly given the name *Lilium convallium* from the Song of Solomon) was garbled into 'liriconfancy'. The link with Solomon's seal was also tenuous. The roots have circular scars left by the leaf stems of previous years, sometimes marked with pentangles, a magical sign of power associated with the wisdom of Solomon, and considered efficacious in sealing wounds or broken bones. Lily of the valley also earned a place in herbals for virtues now recognised as regulating and purifying the circulation.

ABOVE *Lily of the valley is named from the Song of Solomon, 'I am a flower of the field and a lily of the valley.'*
Book of Hours, Flemish, *c.*1500: Add. MS 35313, f.118.

RIGHT *Solomon's seal was also named* Sigillum Sanctae Mariae, *after the Virgin Mary, who, like Solomon, was also linked with the sign of the pentangle.*
Belluno Herbal, Italian, early 15th century: Add. MS 41623, f.42v.

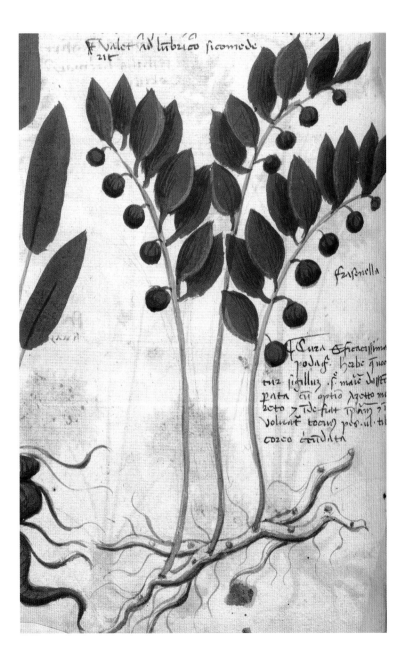

Lupins
Lupinus albus

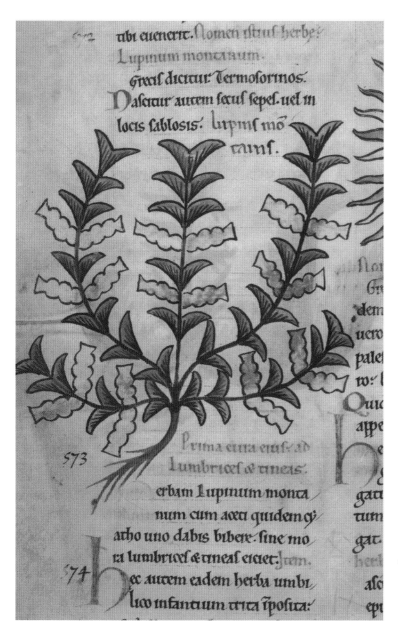

IN THE Mediterranean world lupins were a food crop for man and beast, and also valued for regenerating poor soil. A diet of lupins in excess was mind-altering; thus Protogenus, a painter from Rhodes working on a hunting fresco and subsisting on lupin-meal, created the foam on the jaws of the dogs by throwing sponges charged with paint at them. Whether lupins had reached England by 1200 cannot be proved by the Anglo-Norman herbal shown here, which was a compilation of standard medical texts; but the illustration captured the racemes of white flowers and upward-folding leaves with rhythm and flair.

LEFT *Lupin seeds could be ground into meal or used for healing and cosmetic ointments.*
Tractatus medici de virtutibus herbarum, English, c.1300:
Harley MS 1585, f.51v.

Mandrake

Mandragora officinarum

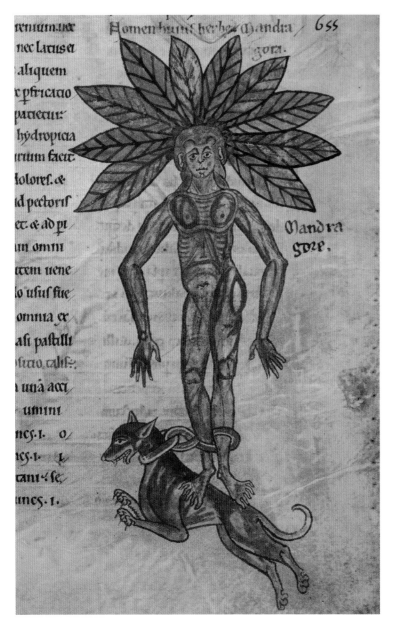

HORRIBLE superstitions accumulated around the mandrake. Its shriek on being uprooted was fatal to hear. One solution was to chain a dog to the plant and abandon it until it became so hungry that it tugged out the mandrake in order to free itself. The forking of the mandrake root into humanoid forms and its human body smell signified its powers. According to the Bible, 'Reuben went in the days of the wheat harvest and found mandrakes in the field and brought them to his mother Leah' (Genesis 30); thus started the colourful life of Joseph, whose mother Rachel used mandrake to conceive him. Although native to warmer climates, mandrakes adapted and spread northwards. In 10th-century England they were called *eordhappel*, earthapple, because the yellow fruit ripens at ground level. The Greeks linked mandrake to Aphrodite (perhaps these were her golden apples), while the Song of Solomon, a masterpiece of seduction, referred invitingly to their smell.

LEFT *Most herbals illustrated the superstitions attached to mandrake as dramatically as possible, while testifying to its value as an anaesthetic. In the words of Bartholomew Anglicanus: 'The rind medled with wine…given to them that shall be cut in their body…so they should not feel the sore knitting'.*
Tractatus medici de virtutibus herbarum, English, c.1300: Harley MS 1585, f.57.

Marigolds

Calendula officinalis and *Chrysanthemum segetum*

MARIGOLDS nearly always featured in medieval gardens, and in the cornfields wild marigolds were such a nuisance that several English kings issued proclamations to eradicate the 'ill weed'. Generally they were known as golds, although a recipe of 1373 for a concoction to guard against plague gave their full name 'seint mary gouldes'. The marigolds of cultivation were named *calendula* because, like the calendar, they were there at the start of every month. They yield an ointment still valued for all types of inflammation, especially varicose veins. The relationship of the flowers to the sun earned them another name, *solsequitur* (sun follower, also applied to chicory), and in churches they were occasionally carved so large that they indeed resembled sunflowers.

ABOVE *The lovely golden yellow of corn marigolds inspired the medieval lament, 'Your hair was like the flower that grows in the barley'.* Bourdichon Hours, French, early 16th century: Add. MS 35214, f.36v.

RIGHT Calendula (marigold), *the curative plant that featured in all herbals.* Circa Instans, Italian, c.1300: Egerton MS 747, f.30r.

Medlars and Pears
Mespilus germanica and *Pyrus communis*

CHAUCER gave the lowdown on both medlars and pears. The Reeve, in *The Prologue to His Tale*, confessed that old men were like medlars, 'til we be roten can we not be rype' (the fruit is unpalatable until late in the season, when it has bletted to a pulp). He called the fruit 'openarse' which, like the French *cul de chien* (dog's arse), referred to the hollow left by the large bud-scar on the small fruit. In *The Merchant's Tale*, when the lovely wife of blind January deceived him, she did so in a pear tree where her lover was waiting, saying suggestively, 'I moste hav of the peres that I see'. Both fruits seem to have been popularly associated with 'looseness'.

RIGHT *Although the curious fruits of medlars provoked coarseness, the masses of spring blossom inspired poetic delight, as in the anonymous poem 'Flower and Leaf', c.1450: 'I was ware of the fairest medlar tree/That ever yet in all my life I see/As full of blossoms as it might be.'*
Bourdichon Hours, French, early 16th century: Add. MS 35214, f.12v.

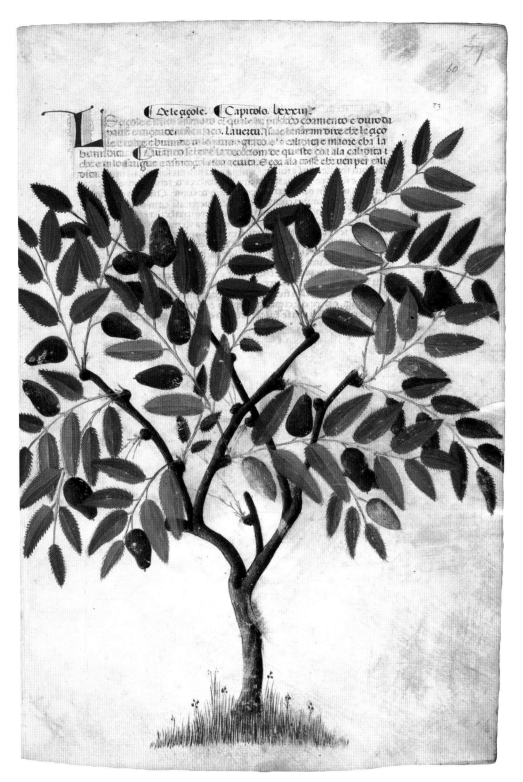

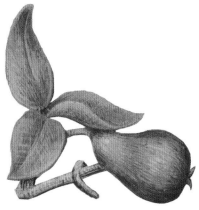

ABOVE *The finest pears in France were introduced from Italy during the 15th century – the Bon Chretien by St Francis de Paul, c.1480, and the Crustunian by Charles VIII in 1495 after his Italian campaigns.*
Bourdichon Hours, French, early 16th century: Add. MS 35214, f. 11v.

LEFT *A mature pear tree laden with fruit.*
Carrara Herbal, Italian, c.1400: Egerton MS 2020, f.60r.

Mulberries
Morus nigra

THE DEEP stain of black mulberry juice, like wine or blood, recalled martyrdom. The introduction of mulberry trees in England was therefore attributed to Thomas Becket or the Knights Templar – although the black mulberry, being native to Asia Minor, was already widely cultivated by the Romans. Silk production, which depended on the white mulberries (*Morus alba*) of China, was a secret locked in the Byzantine and Islamic worlds. Rumours of worms and mulberry leaves had puzzled Virgil and Pliny, and continued to fascinate the medieval mind. Experiments in medieval Spain and Italy, to nourish smuggled silk worms with black mulberry leaves, which they did not relish, were generally short-lived.

LEFT *Black mulberry fruit is far tastier than the white variety.* Bourdichon Hours, French, early 16th century: Add. MS 35214, f.108v.

Mullein

Verbascum thapsis

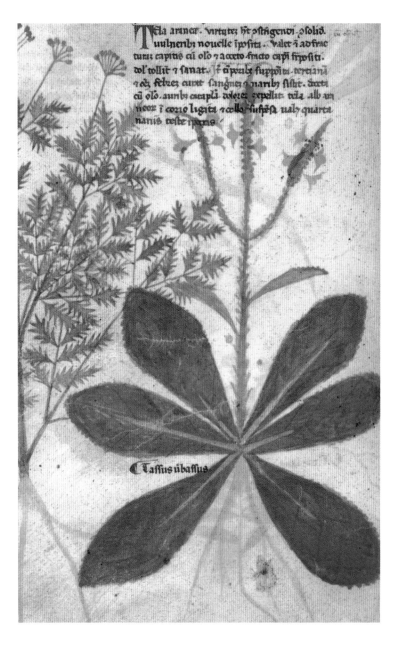

THE ESSENCE of mullein was its hairiness, fluffy and whiteish – *mullein* means 'soft' and *verbascum* means 'bearded'. The hairs, when dried, caught light at the slightest spark, making excellent tinder, or, if dipped in wax, candles and torches. The burst of yellow flowers on the tall stalks intensified the comparison to candle-flame, and also to Aaron's rod in the Bible, which miraculously 'brought forth blossoms'. The belief that mullein was protective, a light in darkness, a promise of renewal, persisted wherever it grew. Meanwhile, the hairs protected the plant itself, conserving moisture and repelling predators.

ABOVE *The English version of* Apuleius Platonicus *stated, 'If a man bear this plant he will not be terrified with any awe, wild beast or evil coming near'.*
Treatise of John Arderne, English, mid-14th century: Add. MS 29301, f.54.

RIGHT *The characteristic burst of yellow candle-flame blossom on the plant's tall stalks reinforced the traditional view of mullein as a healing force.*
Circa Instans, *Italian, c.1300: Egerton MS 747, f.101v.*

Nettles and Hemp

Urtica dioica and *Cannabis sativa*

IN JOHN of Garlande's 13th-century flower garden in Paris, 'by the side grew nettle, thistle and gorse'. Was this an admission of neglect, a barrier, or were they of use? Most medieval herbals mentioned nettles, especially for rashes, burns and rheumatism. The young shoots were nourishing for pottage (stew), pudding and beer, and the whole plant (when dried) for livestock. Also nettles, like their close relative hemp, provided fibre. Nettlecloth was widespread, but nettles had to grow in rich soil for the fibres to be strong – perhaps this explained their presence in gardens. Eventually flax (*Linum usitatissimum*) superseded nettles, as it proved to be a more manageable crop and it also provided linseed oil.

ABOVE *The nettle's sting was compared to original sin – for which reason paintings of paradise gardens would sometimes include a nettle in the grass.* Belluno Herbal, Italian, early 15th century: Add. MS 41623, f.48v.

RIGHT *Hemp was grown for fibre, but its hallucinogenic properties, although known to the Arab world, were not widely recognised in medieval Europe.* Circa Instans, Italian, c.1300: Egerton MS 747, f.28.

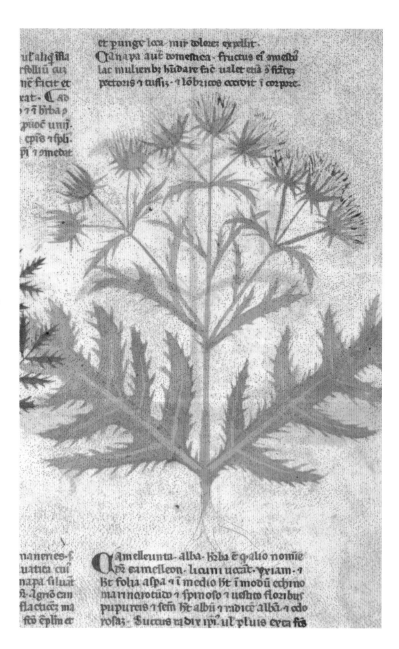

Nigella

Nigella sativa

THE MEDIEVAL name nigella, alluding to the multitudes of little black seeds, was equally applied to campions and the bitter corncockle (see pp. 33 and 42), making identification from plant lists harder. *Nigella sativa*, known as black cumin, was liberally used to spice bread and cakes, and was a favourite condiment of the Arab world, known as black cumin. Their physicians prescribed nigella to relieve headaches and nervous complaints – simply by inhaling the vapours of the crushed seeds. The other, prettier, *Nigella damascena* had the same area of origin, but being purely ornamental, was ignored in the Middle Ages, and only later became known as love-in-a-mist, the favourite of cottage gardens.

RIGHT *Nigella was introduced to European medicine through the medical schools of Salerno, where Arab influence was strong.*
Circa Instans, Italian, c.1300: Egerton MS 747, f.68v.

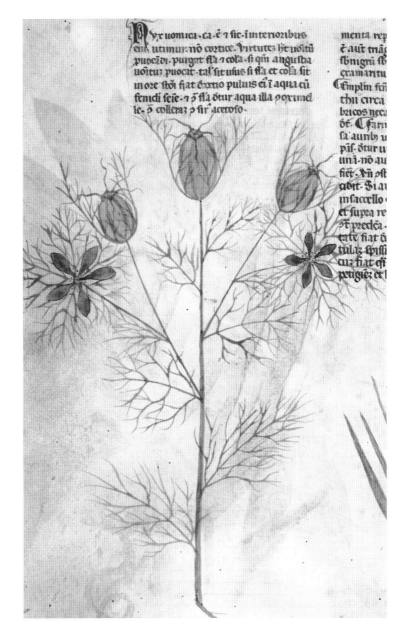

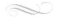

Nightshade
Solanum dulcamara and related species

IRONICALLY, *Solanaceae*, the name of the nightshade family, which includes mandrake (see p. 78), has its derivation from 'solace'. Herbals included these 'comforting' plants for pain relief and anaesthetic, with scant warning of how poisonous they were, though some admitted that they gave 'unquiet sleep'. Henbane (*Hyoscyamus niger*) was recommended for toothache, since the flowers were thought to resemble teeth. Bittersweet (*Solanum dulcamara*) was used for calming convulsions and epilepsy. Belladonna (*Atropa belladonna*) dilated the pupils of the eyes while paralysing the entire nervous system. But, skilfully used, the narcotic elements of these plants gave sensations of flying and erotic delusions – ingredients that were associated with witchcraft.

LEFT *Woody nightshade was generally known in the Middle Ages as bittersweet or dulcamara because the taste is first bitter, then sweet.* Bourdichon Hours, French, early 16th century: Add. MS 35214, f.100.

ABOVE Atropa belladonna *was named after Atropos, the oldest of the Three Fates, who held the shears that cut the thread of life. Belladonna (beautiful lady) reflects one of the plant's side-effects: dilating the pupils of the eyes.* Circa Instans, Italian, c.1300: Egerton MS 747, f.41.

Oranges

Citrus aurantium

ALL ORANGES originated in China, and sweet oranges (*Citrus sinensis*) were unknown in Europe until the 17th century. But Islam introduced the cultivation of bitter oranges (*C. aurantium*) into medieval Spain and Sicily, and elsewhere they became symbols of opulence. Legend had it that the Normans were tempted with a gift of oranges to conquer southern Italy. Heat and wealth were needed to flavour sauces with oranges, and perfume baths with orange water. When the Italian poet Giovanni Boccaccio described the garden of *The Decameron*, 'set around with orange trees', that was exotic, as was the inclusion of oranges in Jan van Eyck's *Arnolfini Portrait* (1434). Anne of Brittany's little orange trees, as depicted by Bourdichon, were a wedding present from Ferdinand and Isabella of Spain, carefully nurtured in her glasshouses.

RIGHT The name 'orange' originated from narandj, an Indo-Arabic word meaning 'perfumed'. In Italian this became arancia, but was confused in medieval French with the town of Orange from where the fruits were distributed northwards.
Bourdichon Hours, French, early 16th century: Add. MS 18855, f.76.

Orchids
Orchis mascula and related species

EUROPEAN orchids, in order to survive dry Mediterranean summers or cold northern winters, evolved two tubers for storing starch, one slightly larger than the other. These earned them the Greek name *orchis*, meaning 'testicle', and an undeserved reputation as an aphrodisiac, which they never shed. But the Church imposed alternative meanings. Orchids that have brown spots on their leaves were said to be marked with the redeeming blood of Christ, and were named Gethsemane or crossflowers, in German *kreuzblumen*. Orchids with tubers shaped more like hands were named *Palma Christi*. This sanctified the best-known orchids, including the early purple orchid (*Orchis mascula*) and the marsh orchid (*Dactylorhiza maculata*).

ABOVE Ophrys apifera, *a bee orchid, one of many orchids adopting female insect forms to trick the male insect into pollinating them.*
Bourdichon Hours, French, early 16th century: Add. MS 35214, f.121.

OPPOSITE Orchis mascula *complete with tubers resembling testicles, which, by the doctrine of signatures, indicated their usefulness in promoting fertility.*
Belluno Herbal, Italian, early 15th century: Add. MS 41623, f.12v.

RIGHT *The marsh orchid* Dactylorhiza maculata, *labelled* Palma Christi *and depicted with tubers deliberately rendered to look more like a hand than the testicle-shaped tubers of* Orchis mascula.
Circa Instans, Italian, c.1300: Egerton MS 747, f.81.

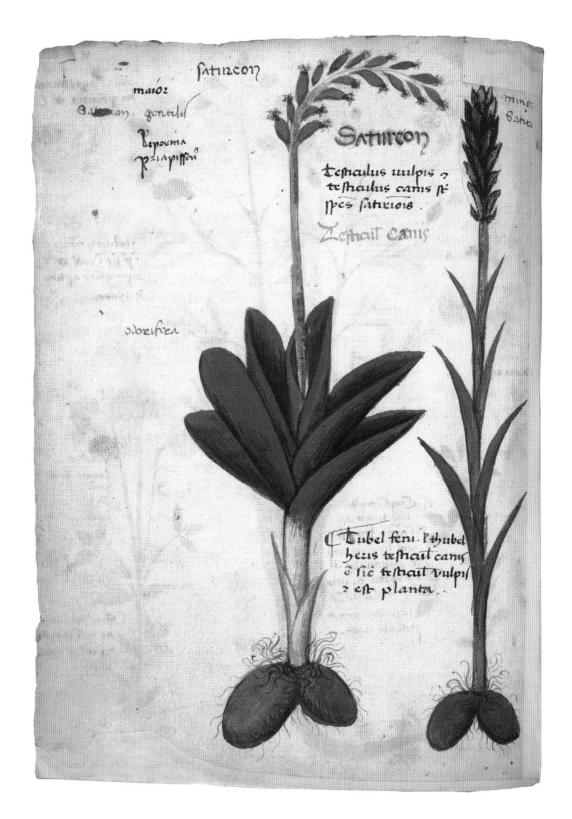

satircon

maioz

Satircon genalis

pepona
prapiss601

odorifica

Satircon

testiculus uulpis ⁊
testiculus canis p̃
pes satirioss .

Testicul canis

Tubel feni. l'thubel
herus testicul canis
⁊ sic testicul vulpis
⁊ est planta .

mino
Satui

Peas

Pisum sativum

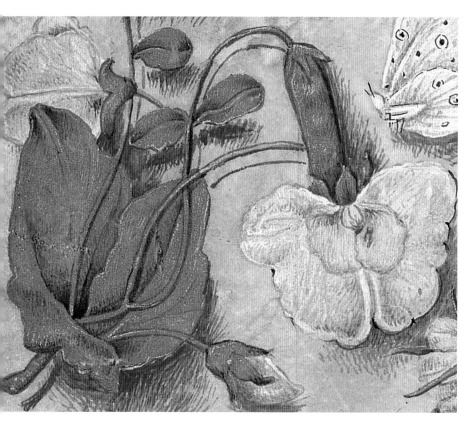

WHEN THE 19th-century monk Gregor Mendel founded the science of genetics, he experimented on peas and established by what ratios dominant genes exceeded recessive genes. His research involved green or yellow peas with smooth or wrinkled coats, and flower colour. This was because cultivated peas came from a mixture of the wild strains eaten since time immemorial by civilisations bordering on the Mediterranean. And Mendel himself might have been fascinated by the colouring of pea flowers in 15th-century manuscripts. White was dominant, then pink, but also combinations of the two, and occasionally blue. Meanwhile, pea pods had first appeared among the drollery borders of early 14th-century East Anglian manuscripts.

ABOVE *In early Books of Hours pea flowers and pods decorated borders around scenes related to the birth of Christ, as if they were symbolically linked.* Isabella Breviary, Flemish, 1497: Add. MS 18851, f.146v.

RIGHT *Blue-flowered peas are among the forms occasionally reintroduced into cultivation.* Bourdichon Hours, French, early 16th century: Add. MS 35214, f.107v.

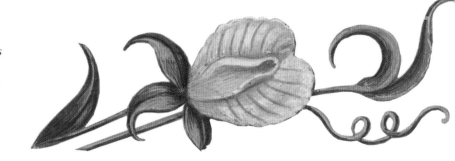

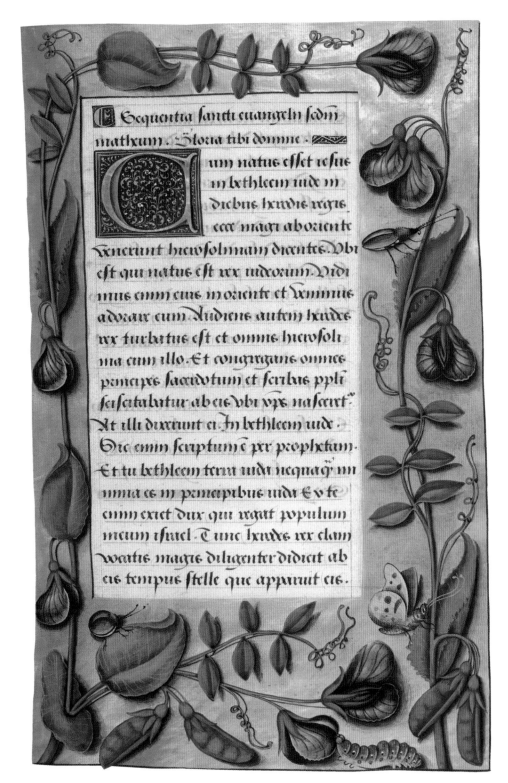

RIGHT *The rich plant colouring shown here resembles that of a wild sweet pea, except with the purple and maroon petals in reverse positions. Sweet peas,* Lathyrus odoratus, *were brought into cultivation from Sicily in the 17th century.*
Bourdichon Hours, French, early 16th century: Add. MS 18855, f.12.

Peonies

Paeonia mascula or *P. officinalis*

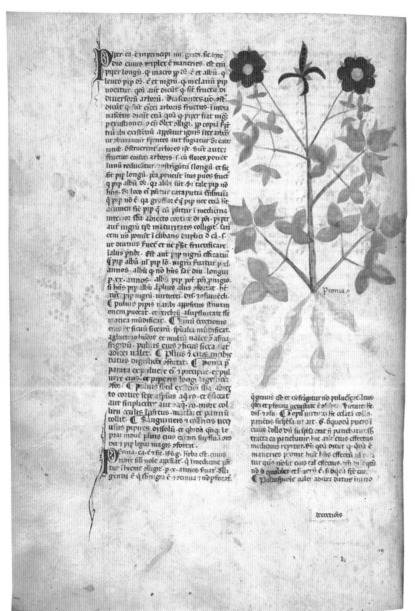

CHINA is the heartland of peonies, and the European peony was displaced in cultivation by the introduction of oriental newcomers in the 19th century. The wild peony remains as elusive as ever, a pinkish-red beauty born on fragile bushes at the edge of dark woodland, mostly in Greece, but also on Steep Holme in the Bristol Channel, which in the 13th century briefly housed a monastic community. Evidently peonies were grown in physic gardens, and their importance was recognised in the fight against infection. In paintings of the Virgin, a peony expressed the concept of 'a rose without a thorn'.

LEFT *In herbals it was recalled that peonies were named after Paeon, a legendary Greek physician who tended the wounded of the Trojan war and after whom the expression a 'paeon of praise' was coined.*
Circa Instans, Italian, c.1300: Egerton MS 747, f.72v.

ABOVE *In 1275 peony roots were supplied for Edward I's favourite garden in the Tower of London; a century later Jean Froissart included them in his poem Le Paradis d'Amour, and in the 15th century peonies appeared in several German paintings of the Virgin in a paradise garden.*
Huth Hours, Flemish, c.1480–85: Add. MS 38126, f.131v.

Pepper

Piper nigrum

THIS MOST important spice of the medieval world originated from the Malabar coast of India, and by the time of Hippocrates the Greeks knew of it as both a medicine and a condiment. Towards the end of the Roman Empire pepper was regarded as so desirable in the European diet that it was offered as ransom to ward off barbarian attacks. When Marco Polo set out in 1271, Venice had become the main entrepot for the pepper trade, using Alexandria, the spice emporium of the Mediterranean, as its supply base. Polo was naturally fascinated by the eastern side of the trade that enriched his hometown. In Aden he watched the *dhows* plying to and from India and the camel caravans setting out for Alexandria. In southern India, he saw pepper cultivated 'in great abundance', and in China he watched it delivered to the eastern capital of Kinsai in daily cartloads. Always he marvelled at how cheap and plentiful it was, while in Europe pepper remained like gold dust – but far more effective for making food palatable.

RIGHT *The climbing pepper plant with its red berries never became familiar in Europe. The unripe berries are collected and sun-dried to become peppercorns, while for white pepper the fruit is ripened and peeled before drying.*
Circa Instans, Italian, c.1300: Egerton MS 747, f.72r.

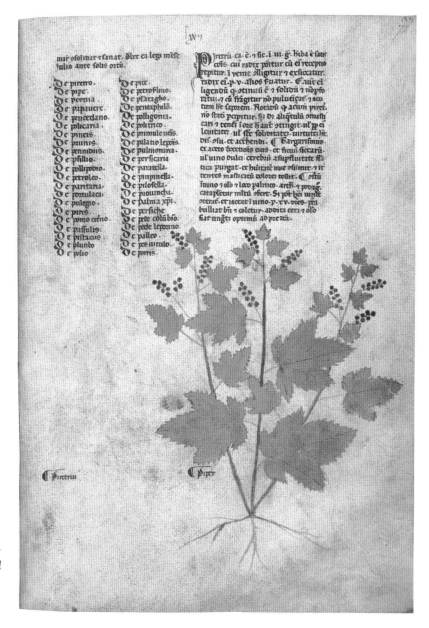

Periwinkles

Vinca major and *V. minor*

STARTING with the old Latin *Vinca pervinca*, meaning 'to bind' and then transformed by the French into *pervenche*, to Chaucer the flower was 'fresh pervink rich of hue'. The binding qualities of periwinkle stems made them ideal for love knots, allegorically binding lovers together; and possibly periwinkle flowers were the origin of 'something blue' for the bride to wear. Periwinkles, like campions, were also called bachelor's buttons because they were used in flirting games (see p. 33). But there was a more sinister side to their binding attributes: they were wound into garlands for those condemned to die – *fiore di morte* in Italian – and in an anonymous English verse:

> crowned one with laurel hye on
> his head set
> other with pervink made for
> the gibet[.]

The German name *sinngrun* (evergreen) added to the flower's symbolism for lovers, and perhaps also for the condemned who hoped for a better life to come.

RIGHT *Periwinkles (top right) and speedwells providing shades of blue in a flower-scattered decorative border.*
Hastings Hours, Flemish, *c.*1480–83: Add. MS 54782, f.49.

Physalis

Physalis alkekengi

DESPITE the modern names Chinese lantern and Cape gooseberry, physalis is a native European plant. The lovely orange seedcase, with its red berry inside, was likened by the Greeks not to a lantern but to a bladder (*phusa*). However, in medieval herbals it was usually given the Arabic name *alkekengi*. Physalis is a member of the dangerous *Solanaceae* family, but is neither poisonous nor narcotic, and it is doubtful whether it has much medical potency either. Physalis never achieved any popular or artistic associations, but in the 15th century its decorative lanterns were often included in millefleurs tapestries.

RIGHT *Physalis berries are edible, but* P. peruviana, *the true Cape gooseberry, tastes far better.*
Circa Instans, Italian, c.1300: Egerton MS 747, f.88.

Pinks

Dianthus species

PINKS were well known in the ancient world of the Greek botanist Theophrastus, who first named them *Dianthus* (God's flower), which greatly facilitated their later adoption into Christian art. He and Pliny also described pinks as 'coronary' plants – worn during festive processions – which may be the origin of the word 'carnation' (from 'coronation'), but the name was more generally linked with the Latin *carnus* (flesh) after pinks' flesh colour. Although various species grew wild throughout Europe, pinks were not mentioned as garden flowers until, late in the 14th century, Friar Henry Daniel acquired one from the queen's own 'herber' for his garden at Stepney. The friar called it *garofila*, a variant on the Italian *garofano*, used for both cloves and carnations, as they share the same heady scent. This was the origin of the name gillyflower. But would the friar have been spicing his wine with pinks if they were rare? Presumably, they were already earning the popular nickname sops-in-wine (see p. 39), and within a few decades the mysterious medieval silence was ended. Pinks became one of the main flowers adorning the borders of 15th-century manuscripts, and a widespread symbol of fidelity in betrothal portraits.

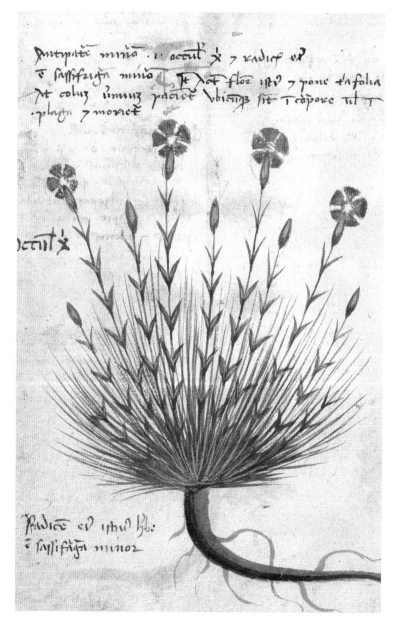

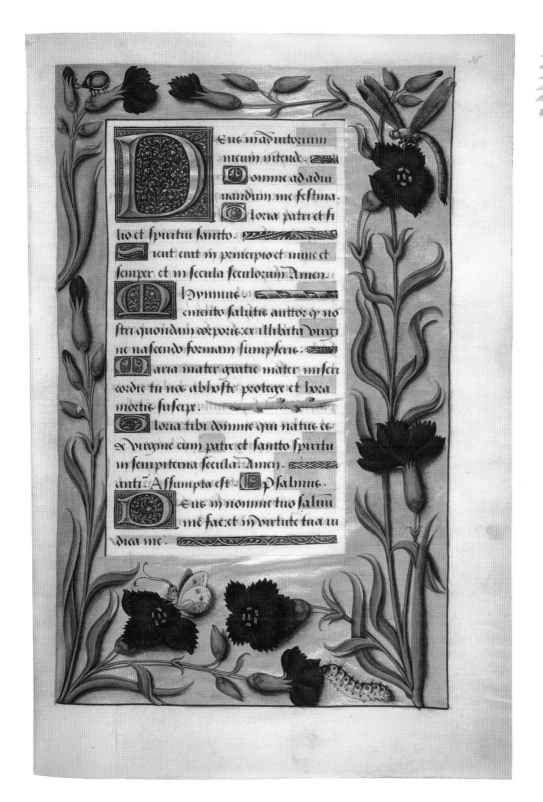

ABOVE *A fine double white pink, no doubt from Anne of Brittany's collection.* Bourdichon Hours, French, early 16th century: Add. MS 35214, f.125v.

LEFT *Possibly the name pinks derives from the flowers' serrated petals, as in pinking shears.* Bourdichon Hours, French, early 16th century: Add. MS 18855, f.35.

OPPOSITE TOP *Sweet williams (Dianthus barbatus) appearing for the first time in manuscript art.* Bourdichon Hours, French, early 16th century: Add. MS 35214, f.104.

OPPOSITE *Another name for pinks is nailflower; likewise 'cloves' derives from the Latin clavus for nail. The resemblance between cloves, wild pinks and nails led to an association with the nails of Christ's Crucifixion.* Belluno Herbal, Italian, early 15th century: Add. MS 41623, f.38v.

Plantain
Plantago major and *P. lanceolata*

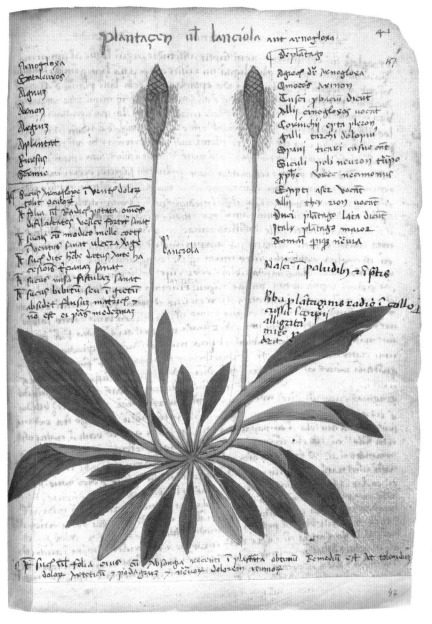

ANY MEDIEVAL painting of Christ or the saints that showed grass at their feet also showed plantain. Its traditional name was waybread and it was believed to grow wherever man's foot trod or, glorified a little, to indicate the passage of sanctified feet; this was certainly the case in Ireland where plantain was dedicated to St Patrick. It was one of the premier herbs for staunching blood and healing wounds – another reason for its inclusion in paintings of the Crucifixion or martyrdom. Faith in its power was based on the concept that a plant itself so resilient would heal torn flesh. The processing of plantain leaves was familiar enough for Chaucer jokingly to describe the Canon's Yeoman as dripping with sweat like 'a stillatorie full of plantayne'.

LEFT *Ribwort plantain (P.* lanceolata*) was recognised by children through the ages as good for shooting the flowers from the stalks, hence the old name 'kemps', meaning soldiers (Swedish* kampa, *Danish* kjaempe)*, and the Latin* lanceolata.

Belluno Herbal, Italian, early 15th century: Add. MS 41623, f.47.

Pomegranates

Punica granatum

POMEGRANATES entered the orchards and mythology of the ancient world before most fruits. The visceral quality of their seeds surrounded by red juice linked them with primal goddesses of birth and death. When the Greek deities Demeter and Persephone inherited these attributes, pomegranates became part of their story and sacred rites. Finally, sanctified by Old Testament references, pomegranates were accepted as a Christian symbol of resurrection, and the burgeoning seeds came to represent the dominions of the Church. The Romans introduced pomegranates into Italy from Carthage, calling them *Mala punica* (Carthaginian apples). But they remained a rarity in medieval Europe, and Friar Henry Daniel admitted that in London 'it groweth among us gladly but it fruiteth not'.

ABOVE *The flowers of pomegranate were valued by herbalists for their astringent properties.* Bourdichon Hours, French, early 16th century: Add. MS 35214, f.112.

RIGHT *The seedy fruits of pomegranate (far right) gave rise to their Latin name, granatum (many-seeded). They became the heraldic emblem of Granada.* Bourdichon Hours, French, early 16th century: Add. MS 35214, f.112.

Poppies
Papaver somniferum and *P. rhoeas*

FROM ITS heartlands in Asia Minor, the opium poppy spread all across the ancient world, deeply valued for its pain-deadening qualities, while the seeds were gathered to spice food and produce oil. The medieval use of opium was sensational but not recreational. In Chaucer's *The Knight's Tale*, Palamoun escaped a gaoler that he 'drugged with narcotics and opie of Thebes fyn'; and in Christopher Marlowe's play the Jew of Malta 'drank poppy and cold mandrake juice, and being asleep belike they thought me dead, and threw me o'er the walls'.

The translucent red of field poppies may not have been appreciated in cornfields, but their propensity to spring up in the disturbed soil of battlefields was poignantly referenced in the *Chanson de Roland, c.*1100: Charlemagne, searching for the body of his beloved nephew Roland, who died guarding the mountain pass of the Pyrenees against the 'paynims' (pagans) advancing through Spain, crossed the meadow at Roncevalles:

> As the king goes his nephew for to seek
> How many flowers he finds upon the lea
> Red with the blood of all that chivalry.

Primroses and Cowslips
Primula vulgaris and *P. veris*

PRIMROSE means the first flower of spring, deriving from the Italian *primavera* and French *primeveize* (spring). But except for Hildegard of Bingen and Friar Henry Daniel, medieval gardeners or herbalists seldom mentioned them.

Cowslips were better loved. Being gently narcotic, they were made into soothing syrups, and they were also used to 'take off spots and wrinkles and other vices of the skin'. This potential was suggested either by the wrinkled surface of the leaves, or by the little red freckles at the edge of their petals. The flowers, clustered on a central stalk, were reminiscent of bunches of keys. The idea that these symbolised the keys of heaven was especially clear in the German name *himmelschlussel*.

LEFT *Shakespeare twice spoke of the 'primrose path' as the way of dalliance that led to perdition, and Chaucer in The Miller's Tale described a temptress as 'a prymerole…for any lord to leggen in his bed'.* Bourdichon Hours, French, early 16th century: Add. MS 35214, f.44v.

ABOVE *For cowslips the English favoured the undignified old name cu-sloppe, perhaps a misunderstanding of the French coucou, as in cuckoo-flower.* Bourdichon Hours, French, early 16th century: Add. MS 35214, f.19v.

Quinces and Peaches
Cydonia oblonga and *Prunus persica*

SINCE the apple of Eden was merely described as a fruit, and Aphrodite's apple was golden, the ancient myths may in fact have revolved around quinces – labelled *pommes de paradis* by Bourdichon. Although quinces ripen to a glowing, scented yellow, the flesh seldom softens. In the words of a 10th-century Arab poet from Cordoba, 'it has the perfume of a loved woman and the same hardness of heart'; but the association of quinces with love made them a traditional part of wedding feasts. Charlemagne listed quinces and peaches among the trees in his empire, and gradually both were cultivated further north. In 1275 three quince and two peach trees were supplied for the royal gardens in the Tower of London, and a century later Chaucer's list of 'homely trees' included both.

LEFT *Peaches were not always succulent in northern Europe, and apricots still less so, until sweeter varieties were cultivated in the 16th century.* Bourdichon Hours, French, early 16th century: Add. MS 35214, f.123v.

ABOVE *Also known by the name* pomy codogny *or* coing *in French, the Spanish and Portuguese called quinces* marmelo *and created the original marmalade from them.* Belluno Herbal, Italian, early 15th century: Add. MS 41623, f.122.

Redcurrants, Blackcurrants and Gooseberries
Ribes rubrum, R. nigrum and *R. uva-crispa*

THERE was no classical or biblical authority to give status to the little edible fruits of rural Europe, and no sugar to make them more palatable. They were used in sauces for meat and oily fish, but were seldom mentioned and tended to share the same name. In England gooseberries were sometimes distinguished by reference to their thorns, but this entailed confusion with buckthorn. In France they were all called *groseille*, meaning 'crisp berry', which was the derivation of gooseberry. But during the 15th century redcurrants far outstripped the others, both in cultivation and in art. Their fruit, glistening like jewels or drops of blood, became a symbol of the Passion of Christ.

BELOW *Gooseberries were obviously acceptable to the Queen of France, or they would not have been included in the courtly manuscripts, but blackcurrants did not appear in any medieval work.* Bourdichon Hours, French, early 16th century: Add. MS 35214, f.7v.

RIGHT *Redcurrants at their most decorative.* Huth Hours, Flemish, c.1480–85: Add. MS 38126, f.78v.

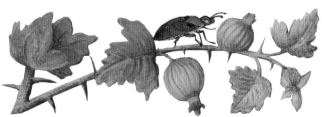

Rosemary
Rosmarinus officinalis

ROSEMARY means 'sea spray' – a poetic description of the Mediterranean coastal hills where rosemary bushes flowered in shades of blue and white. According to Christian legend, the flower was white until the Virgin draped her cloak over it. Originally rosemary signified remembrance because, being tonic and stimulant, sprigs were worn to refresh the mind while studying. Later, practical usage turned to symbolism and rosemary was worn at weddings in token of fidelity and at funerals in memory of lost love. It was also burnt like incense to guard against pestilence. But in northern Europe rosemary went unmentioned until the 14th century, when, in Paris, it was listed in the royal gardens at St Pol. Friar Henry Daniel said rosemary cuttings were first sent to England by the Countess of Hainault, *c.*1340, to her daughter Queen Philippa (with motherly advice on putting it under Edward III's pillow to promote fidelity). Later, rosemary became the emblem of Richard II's queen, Anne of Bohemia, after whom it was painted in the Wilton Diptych (*c.*1395-1399).

RIGHT *Of rosemary, Friar Henry Daniel wrote, 'It is a holy plant and with folk that be rightful and just gladly it groweth and thriveth'.*
Circa Instans, Italian, c. 1300: Egerton MS 747, f.85v.

Roses

Rosa gallica and *R. alba*

WHEN Guillaume de Lorris created the allegorical *Roman de la Rose* (Story of the Rose), *c*.1260, about the search for love in the form of a red rose, he reiterated that the finest roses came from the land of the Saracens. Although wild roses rambled sweetly through the hedgerows of Europe, in gardens the deep red *Rosa gallica* was transformed when Thibault, the troubador Count of Champagne, returned from his crusades in 1240 with a cultivated form, establishing it in the gardens of Provins. This Rose of Provins, the flower of romance, was also the apothecaries' rose. The medicinal qualities of the preserved petals produce an astringent tonic, as well as fine perfume. The association of red roses with Aphrodite and love was so strong that possibly the goddess and the flower were introduced to Greece from the east simultaneously, along with stories of her many liaisons. What was spoken *sub rosa* (under the rose, or in secret) started with the illicit passions she provoked, and rose-strewing ceremonies were originally in her honour. The early Church frowned upon roses, but in time it succumbed, even to scattering roses in honour of the Virgin.

The oldest white rose of cultivation, *R. damascena*, the perfumers' rose yielding attar of roses, was first described by Herodotus (*c*.450 BC) as a rose from the east with a hundred petals. Its Roman name, *centifolia*, being a great exaggeration, was reallocated in the 17th century to a pink cabbage rose, newly developed. The white rose grown in medieval Europe was generally *R. alba*, a hybrid between the damask rose and native wild roses. Like all medieval roses, it was semi-double with a mass of golden stamens signifying its fertility, and – since all roses contain red genes – a tendency to blush pink. It was easier for a white rose to attain mystic status. Dante used it for his description of paradise, with God's glory at the golden centre and the blessed sitting in tiers of white petals. Rose windows of stained glass glowed with heavenly light in cathedrals. The Virgin was 'a rose without a thorn'; while in colour symbolism, the three virtues – faith (white), hope (green) and love (red) – could be expressed by painting a trellis full of roses.

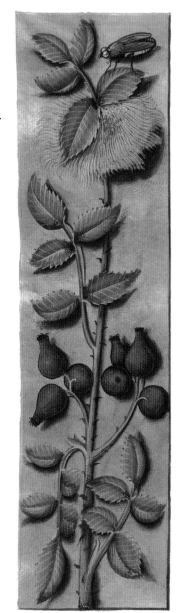

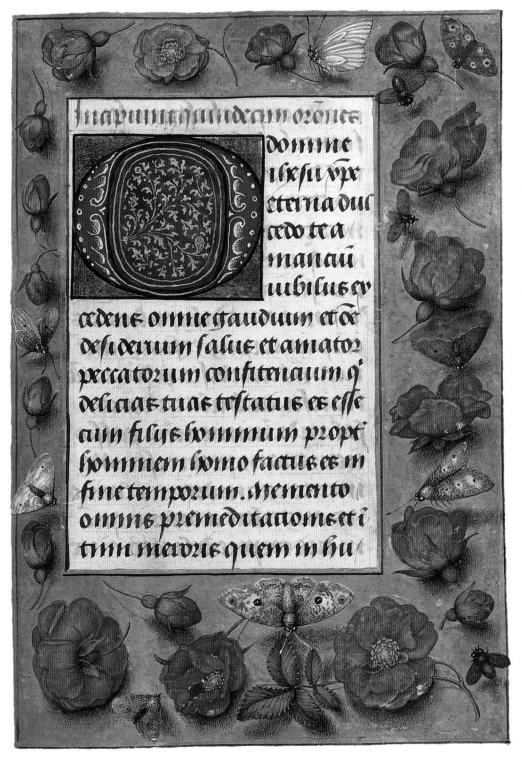

LEFT *The classic red rose* Rosa gallica, *known as the* French *or* Gallic rose *and the rose of Provins, grew wild in southern Europe.*
Hastings Hours, Flemish, c.1480–83: Add. MS 54782, f.226.

OPPOSITE TOP *The five-petalled outline of the wild dog rose,* Rosa canina, *is often seen in stylised form in medieval heraldry. The wild rose was also known as wild briar, rose briar, dogberry and sweet briar.*
Book of Hours, Flemish, c.1500: Add. MS 35313, f.205.

OPPOSITE RIGHT *Rosehips, the fruit of the rose plant, were not used in medieval medicine, but the robin's pincushion (top) created by a parasitic wasp was powdered and taken for internal disorders.*
Bourdichon Hours, French, early 16th century: Add. MS 18855, f.58v.

OPPOSITE BOTTOM *The delicate petals of the white garden rose,* Rosa alba, *range from pearly white to blush pink.*
Isabella Breviary, Flemish, 1497: Add. MS 18851, f.182.

Saffron crocus and Safflower
Crocus sativus and *Carthamus tinctorius*

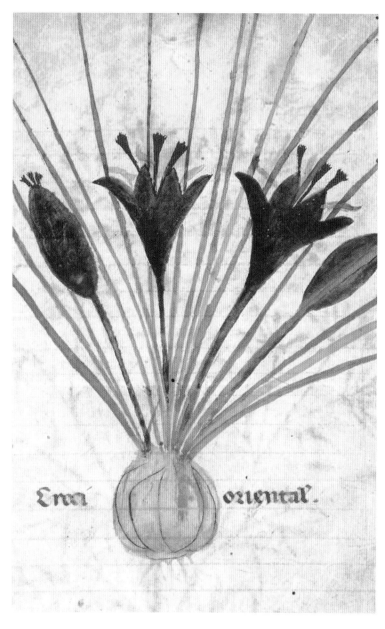

Erva oriental.

HARVESTING Saffron is so labour-intensive that, in order to yield a little scoop, nimble-fingered workers must pick the stigmas out of four thousand crocuses. It gives food a warmly bitter flavour, a fleeting yellow colour, and is used to dye rare fabrics. So saffron became an adjective – for Homer's clouds of morning, a Persian king's shoes, or the skirts of girls dancing for a Chinese emperor. Among the luxury commodities of the Arab world, saffron (a corruption of the Arabic *sahafara*) ranked high, and its cultivation spread to Spain and even to 14th-century England. Naturally, adulterants and substitutes were sought, the best being the ground-up petals of safflower, an Asian thistle of widespread distribution known as bastard saffron. True saffron had a reputation for causing hilarious laughter if taken in excess, a claim rarely tested.

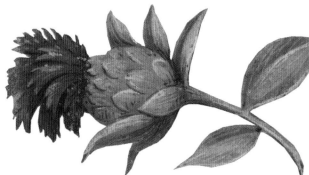

Sage
Salvia officinalis

'WHY DIE with sage in the garden?' This maxim, known all across medieval Arabia and Europe, reflected the reputation of this tonic. *Salvias* (the name meant 'salvation') featured in many potions, one of which was an infusion of sage, speedwell and betony; and Friar Henry Daniel described the 'nerval' of Lady Zouche (the best lady healer in England), which included white ambrose, probably wood sage (*Teucrium scorodonia*). Those who described pleasure gardens also included sage, small wonder since it has fascinating variations of leaf colour; and clary sage (*Salvia sclarea*) offers further subtleties of green, white, pink and blue (as well as treating sore eyes). Sage was also used as a tooth whitener, except perhaps by readers of Boccaccio, who told of an unfortunate young man walking with his girl in a garden who rubbed his teeth with sage leaves and dropped dead. The culprit was a venomous toad lurking at the roots, which would explain the frequent companion planting of rue (*Ruta graveolens*) to repel such horrors.

RIGHT *Sage is an anglicized version of the French* sauge, *both derived from the Latin* salvia.
Circa Instans, *Italian, c.1300: Egerton* MS *747, f.93.*

Snowdrops and Snowflakes
Galanthus nivalis and *Leucojum vernum*

DID Theophrastus mention snowdrops? They originate from eastern Europe, but he called them *leucoion* (white violet), the name subsequently given to snowflakes. Snowdrops acquired a religious significance because their February flowering coincided with Candlemas, the feast of the purification of the Virgin after childbirth, which included scattering white flowers before her image in the candlelight. Snowdrops have naturalised on the sites of monasteries and churchyards, and their old name is candlemas bells (in Flemish *lichtmisbloem* and in French *violette de la chandaleur*), which reinforces the idea of monks and pilgrims returning with snowdrop bulbs and their attributed powers from journeys to Rome and beyond. But there is no medieval record of snowdrops.

ABOVE *A snowflake or* Leucojum *making one of its rare appearances in a manuscript border.*
Book of Hours, Flemish, c.1500: Add. MS 35313, f.222v.

RIGHT *Snowdrops made their first appearance in the Bourdichon manuscripts. Their next was in the flower paintings of Jan Brueghel and his contemporaries.*
Bourdichon Hours, French, early 16th century: Add. MS 35214, f.17.

Sorrels and Woodsorrels
Rumex acetosa and *Oxalis acetosella*

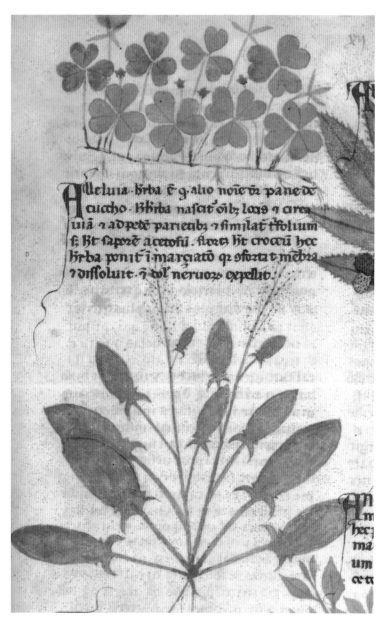

SORRELS, which have spinachy leaves, were cultivated for salads, potherbs and a green sauce eaten with fish. They owe their flavour to a potash compound which is also present in woodsorrel, an unrelated plant with trefoil leaves (sometimes called shamrock). Herbalists understandably classified them together, and gave them names indicating acidity – acetosa, oxalis and sorrel from the French for 'sour'. Woodsorrels were associated with springtime, flowering early and being freshly available to eat, and they gained the grateful nickname 'alleluyahs'. As an Easter plant, or because their trefoil leaves symbolised the Trinity, woodsorrels were favoured by quattrocento (14th-century) Italian painters especially Fra Angelico. Bistort (*Polygonum bistorta*), which is related to sorrel, was another Easter food, also known as passion dock, and cooked in special puddings. Sometimes it was taken to aid conception and delivery, and its original use was probably magical, not Christian, and linked with seasonal regeneration.

LEFT *Woodsorrel (top) and sorrel (bottom) were classified together in medieval herbals because of their similar taste.* Circa Instans, *Italian, c.1300: Egerton* MS 747, f.12.

Stocks and Sweet rockets
Matthiola incana and related species

STOCKS were loved for their scent, and therefore grouped either with violets or gillyflowers (see p. 96). Their four-petalled, cruciform flowers gave them a natural Christian symbolism, and they appeared often in paintings and manuscripts. This also applied to sweet rocket or dame's violet with its dense clusters of white flowers, giving off scent only at night and therefore named *Hesperis matronalis* (*Hesperus* being the evening star Venus, although both plant and star were rededicated to the Virgin). Another planetary link was made for honesty, with its silver seedpods resembling little moons, which inspired its Latin name *Lunaria biennis*. All these crucifers, like cabbages, were wholesome plants that could be eaten; hence the adage *in cruce salus*, 'health is in the cross'.

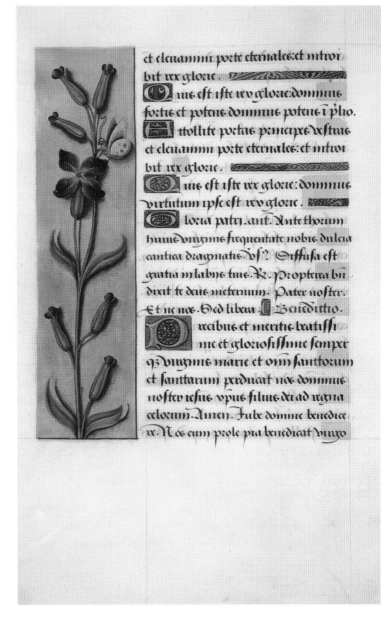

ABOVE *Sweet rocket was sometimes hard to identify in medieval plant lists because, due to its sweet smell, it was one of several flowers named violet.*
Bourdichon Hours, French, early 16th century: Add. MS 18855, f.96v.

RIGHT *The various colours of stocks were appreciated, and Bourdichon's also came in shades of white, purple and pink.*
Bourdichon Hours, French, early 16th century: Add. MS 18855, f.19v.

Strawberries

Fragaria vesca and *F. moschata*

LIKE most fruit, strawberries evoked temptation, and a well-known Virgilian proverb warned of snakes sleeping coiled in the cool of their leaves. Hieronymus Bosch used strawberries as a symbol of fleeting and dangerous pleasures in his *Garden of Earthly Delights* (*c*.1505). The enormous size of his strawberries was another deception, as European varieties remained tiny, though vigorous, until hybridised with American species. The Old English name *streawberige* derived not from straw but from the runners strewing fresh plants in all directions. In Christian art strawberries lost their sinister aspect; the perfect fruit with no pips or peel symbolised the Virgin; the white flowers and red fruit represented purity and martyrdom; the threefold leaves the Trinity. When illuminators started to experiment with illusionism they first put little shadows around white strawberry flowers to lift them from the page.

ABOVE *The small wild strawberry* Fragaria vesca *was common in Europe.*
Huth Hours, Flemish, *c*. 1480–83: Add. MS 38126, f.210.

RIGHT *The slightly larger* Fragaria moschata *grew wild in upland woods.*
Belluno Herbal, Italian, early 15th century: Add. MS 41623, f.17r.

Tansy and Feverfew

Tanacetum vulgare and *T. parthenium*

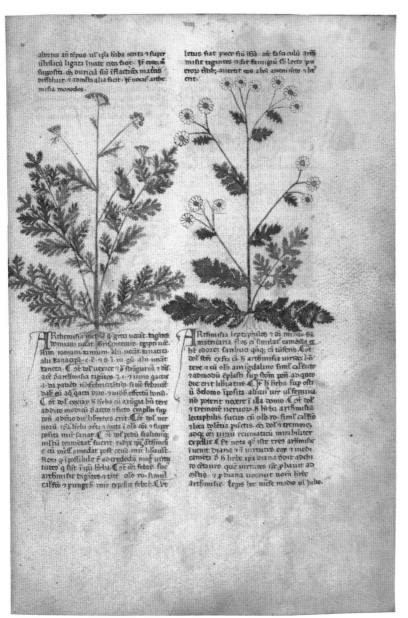

TANSY was used like artemisia and fleabane to drive away bedbugs and flies. But the Latin *tanacetum*, in Greek *athanasia*, was the plant used by the gods to enable mortals to inhabit Olympus. Ganymede, the beautiful youth whom Zeus bore off to be his cupbearer, was given *athanasia*. Not that herbals suggested drinking infusions of tansy to become immortal, but they mentioned its use in preserving dead bodies from corruption. All members of the *Compositae* family with a sharp, insect-repelling aroma were used in embalming ointments – 'preserving the body unto everlasting life'. It was therefore as a plant of death and resurrection that the Flemish painter Jan van Eyck included tansy in the Ghent Alterpiece or *Adoration of the Mystic Lamb* (1432).

Tansy was an essential ingredient of Easter cakes – there was even an arcane ceremony where medieval bishops played ball with their congregations and rewarded the victor with a tansy cake.

LEFT *Tansy (left) and feverfew (right) were classified in herbals alongside artemisias and shared their medicinal importance.*
Circa Instans, Italian, c.1300: Egerton MS 747, f.8.

Thistles

Cirsium vulgare and related species

cvgo prlatus ad cos fozas.7 dirit:
Quam accusationem affetis adu
sus bominnem bunc.Rndecunt. et
dirctunt ei.Si non effet bic male
factoz.non tibi tradidiffemus eum.
Dint ergo eis pylatus.accipite eu;
uos.7 fatin legem uram uidicateeu
Dirctunt ergo ei iudei.Robisnon li
et interficete quemqz.Vt sermo ibu
implectur quem dirit significans
qua morte eet moriturus.Introiunt
ergo iterum in pretozium pylatus.7
uocauit ibm 7 dirit ei.Tu es rer iude
ozum.Rndit ibc.a temetipo bec dicis
an alij dirctunt tibi de me.Rndit py
latus.Nunqz iudens ego sum:Rens
tua 7 pontifices tradidecunt te michi.
Quid fcasti:Rndit ibc.Regnuz mei
non est de boc mundo.Si er boc mu
do effet regnum meum.ministri 2

EVERYDAY experience of tending poor land amply reinforced the biblical curse of Adam: 'thorns also and thistles shall it bring forth to thee'. In Christian paintings thistles represented the bodily and spiritual torment of the person portrayed, especially John the Baptist in the wilderness. But if the spines could be circumvented, many thistles yielded healthy, if flatulent, food and had the reputation of dispelling melancholy, which in the Middle Ages was synonymous with cleansing the blood. In a wall hanging embroidered with 'thrissils' the heraldic plant of Scotland made its first appearance in 1488, listed in the property of James III. The Latin motto, meaning 'No one attacks me with impunity', may have come later.

LEFT *A contemporary Book of Hours for Mary, Duchess of Burgundy, was in production when she was killed in a hunting accident in 1482. Her bereaved husband, Maximilian of Austria, had most of the remaining borders decorated with thistles.*
Huth Hours, Flemish, c.1480–85. Add. MS 38126, f.198r.

ABOVE *The bitter properties of blessed thistle, Cnicus benedictus, traditionally thought to be cleansing and purifying, were prescribed for digestive problems and heartburn.*
Circa Instans, Italian, c.1300: Egerton MS 747, f.108r.

Vervain and St John's wort
Verbena officinalis and *Hypericum perforatum*

VERBENAE in Latin referred to plants used in sacrifice and purification. Medieval herbals attached the name to vervain, adding *herba sacra* (holy herbs) and *herba bona* (good herbs). Northern Europe had strong traditions of its own, prophecies and incantations, which Christianity sanctified by rededicating vervain to St John. His day in June was a festival of midsummer bonfires, known in France as *feux de joie* (fires of joy) because they burnt away disease and misfortune. In Italy vervain was called *erba san Giovanni* because of its role in the fumigation ceremonies. In England hypericum, with its golden midsummer flowers, was named St John's wort, but vervain was also used in the midsummer rituals. The French proverb *Avoir toutes les herbes de St Jean* now means 'covering any eventuality', but used to indicate exorcism.

LEFT *Vervain, also known as enchanter's plant, was used by medieval herbalists to treat nervous conditions and insomnia.*
Circa Instans, Italian, c.1300: Egerton MS 747, f.16r.

RIGHT *In a traditional ballad a demon lover crooned: 'If thou hope to be mistress mine /Lay aside the St John's wort and the vervine.'*
Treatise of John Arderne, English, mid-14th century: Add. MS 29301, f.51v.

Vines

Vitis vinifera

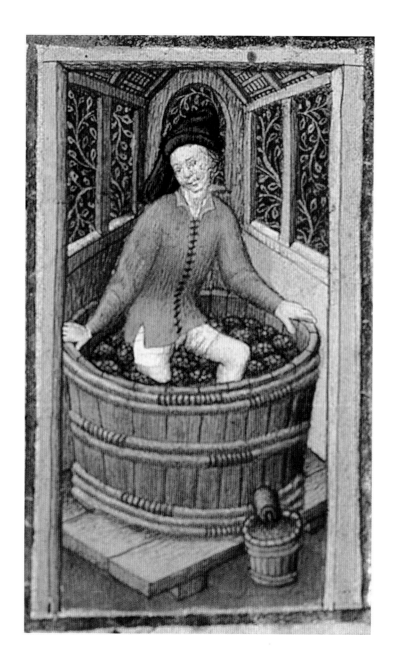

VINES combined decoration and symbolism of many kinds, from 'wine that maketh glad the heart of man', via the shameful drunkenness of Noah and the 'sour grapes' of Ezekiel's prophesy, to the Last Supper and the image of Christ crucified. Innumerable grapevines were carved in churches and painted in the margins of manuscripts, until the designs were called vignettes and the illuminators vignetteurs. Viticulture was practised all over Europe, as far north as the climate allowed. In 11th-century England, the Domesday Book cited thirty-eight vineyards. Some years later the Prior of Llanthony had 'fruitful vines', the Abbey of Bury St Edmunds made wine for the solace of sick monks, and the Earl of Essex turned Smithfield in London into a vineyard. Throughout Europe the records of royal and noble estates mentioned vineyards, but it was probably in monasteries that the greatest vintages were found.

LEFT *Grape-treading in autumn, from a calendar page for September.* Bedford Hours, English, 1414–22: Add. MS 18850, f.9.

OPPOSITE *Among the many Christian texts relating to vines were Christ's own words, 'I am the vine, ye are the branches' (John 15).* Carrara Herbal, Italian, c.1400: Egerton MS 2020, f.28.

ne batidon a la dolega e sita cura e cosa aia regna ulcerosa e no ulcerosa
e couesse amana che se faca lunidon a questa dolega lanare et mem
bro cum el sal tinto ecum lo ulio spesse fiesetauorel ipius. La lagre
ma che uen fuza dele uenere dela uigna quando la e freschamente re
colte dela uigna e po metu in lo fugo cum un cauo chauro. dala tuto cauo
uen fuza questa lagrema a muto sudore. ha uertu demoicari le ueruce
che uen chiama mirtince. La uertu de la cendere de questa uenceia e dela
cendere dele grasse dela uua de questa quando sen fa empiasto cum

Violets and Violas

Viola canina and *V. tricolor*

A 6TH-CENTURY Bishop of Poitiers wrote 'none of the sweet herbs can equal the nobility of the dark violet'. It represented the Virgin's sweetness and humility (partly because the flowers droop on their stalks); and also her sorrows, because violets were the chosen flowers to scatter on graves, a pre-Christian association. Their name incorporates a Greek lament *io*, which was also the name of an unfortunate nymph whom Zeus pursued. Violas, though they bore the same letter-code, were more cheerfully linked with lovers, and had suggestive country names like heartsease and love-in-idleness. The French called them *pensées*, meaning 'thoughts' (the origin of pansy), while for Shakespeare's Oberon they were the 'little western flower once white now purple with love's wound' – a flower of enchantment.

ABOVE *Violets flower in March, at the right moment to be scattered before the Virgin on Lady Day, marking the Feast of the Annunciation.*
Isabella Breviary, Flemish, 1497: Add. MS 18851, f.472v.

RIGHT *Violets giving a fine example of medieval botanical illustration that was both accurate and aesthetically pleasing.*
Carrara Herbal, Italian, c.1400: Egerton MS 2020, f.94r.

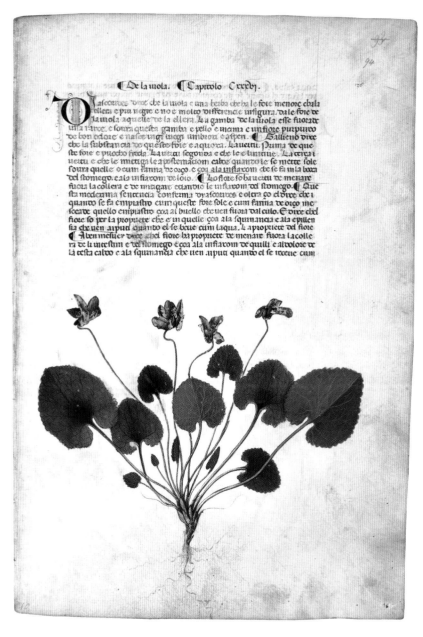

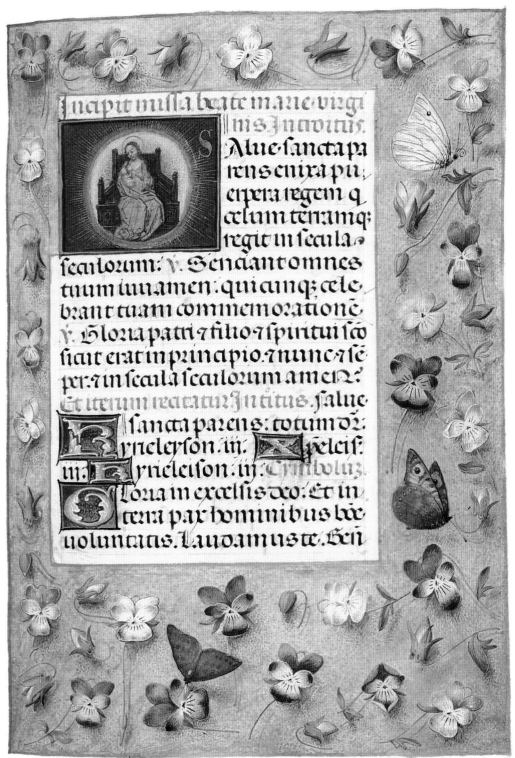

LEFT *Violas symbolised the Trinity because of their three-coloured petals. Their colour variations, as shown in this decorative border, fascinated manuscript illuminators.* Huth Hours, Flemish, c.1480–5: Add. MS 38126, f.50.

Wallflowers
Cheiranthus cheiri

WALLFLOWERS of various colours, including some streaked, grew in the Islamic gardens of Spain and were named *cheiry*, meaning 'hand-flower' or 'posy', because of their sweet scent. They remained rare in art and garden lists, but became emblematic flowers for troubadors due to the sad tale of the daughter of the Earl of March. Although betrothed to a Scottish prince, she fell in love with a wandering minstrel. From her turret she threw him a wallflower as a pledge, but in attempting to join him she fell to her doom and wallflowers became the token of mournful fidelity, frequently lamented by troubadors. The story suggests that wallflowers grew on the battlements of medieval Scottish castles.

RIGHT *These yellow wallflowers retain the basic wild colour and possibly they were not yet much developed as garden flowers in northern Europe.*
Bourdichon Hours, French, early 16th century: Add. MS 35214, f.43.

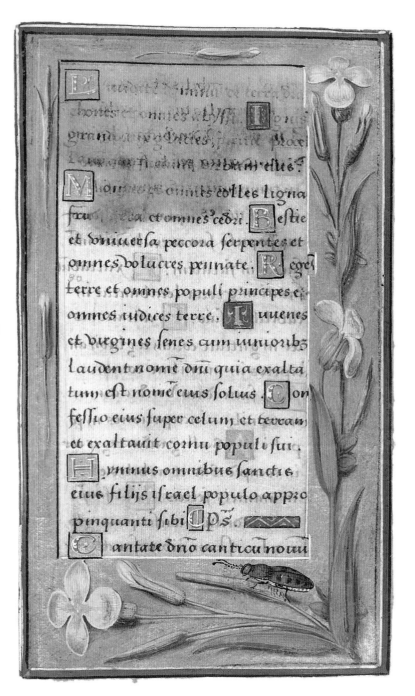

Waterlilies
Nymphaea alba and *Nuphar lutea*

WATERLILIES were familiar to all who lived near lakes of sluggish water, and the 13th-century sculptor who carved them among the plants in the Angel Choir of Lincoln Cathedral made sure to indicate the ripple of water under their leaves. In herbals they were attributed many uses. The more fanciful included steeping the rhizomes in tar and applying as a hair restorative; but the leaves could be genuinely efficacious as poultices for skin eruptions, and decoctions of the powdered roots were prescribed for tumours and ulcers. European waterlilies never achieved the otherworldly reputation of the hallucinogenic blue lotus of Egypt (*Nymphaea lotus* and *N. caerulea*) which were arranged into wreaths for the mummies of pharaohs; nor the sacred lotus of India and China (*Nelumbo nucifera*) on which gods and buddhas were seated. But the name *Nenuphar*, used in medieval European herbals for waterlilies, derives from a Sanskrit word, hinting at a connecting strand of knowledge.

ABOVE AND RIGHT *The decorative qualities of waterlilies were heralded in European art for the first time in the Bourdichon Hours. The alcoholic scent of the yellow* Nuphar lutea (above) *attracts pollinating beetles, and the seed capsule is shaped like a little green carafe, inspiring the nicknames brandy bottle and, in Old Scottish, can-dock.*

Bourdichon Hours, French, early 16th century: Add. MS 35214, ff.94v–95r.

Further Reading

Index of Manuscripts

Blunt, W. and Stearn, W.T.
The Art of Botanical Illustration
(London, 1950; new edition 1994)

Coates, A.
Flowers and their Histories
(London, 1956; repr. 1968)

Collins, M.
Medieval Herbals: the Illustrative Traditions
(London, 2000)

Grieve, M.
A Modern Herbal
(London, 1931; repr. 1976)

Harvey, J.
Medieval Gardens
(London, 1981)

Hobhouse, P.
Plants in Garden History
(London, 1992)

Kren, T. and McKendrick, S.
*Illuminating the Renaissance: the Triumph
of Flemish Manuscript Painting in Europe*
(London, 2003)

McKendrick, S.
*Flemish Illuminated Manuscripts
1400–1550*
(London, 2003)

Add. ms 35214, f.100: 86
Add. ms 35214, f.104: 96
Add. ms 35214, f.106: 62
Add. ms 35214, f.107v: 90
Add. ms 35214, f.108v: 82
Add. ms 35214, f.109: 108
Add. ms 35214, f.121: 88
Add. ms 35214, f.123v: 103
Add. ms 35214, f.112: 99
Add. ms 35214, f.125v: 97

Add. ms 35313, f.118: 76
Add. ms 35313, f.205: 106
Add. ms 35313, f.222v: 111

Add. ms 35313, f.27: 7
Add. ms 35313, f.29v: 40
Add. ms 35313, f.42v: 47
Add. ms 35313, f.50: 121
Add. ms 35313, f.78v: 104
Add. ms 35313, f.82v: 27
Add. ms 35313, f.82v: 33
Add. ms 35313, f.118: 76
Add. ms 35313, f.131v: 92
Add. ms 35313, f.198: 116
Add. ms 35313, f.205: 106
Add. ms 35313, f.210: 114
Add. ms 35313, f.222v: 111
Add. ms 35319, f.45v: 75

Add. ms 41623, f.3: 16
Add. ms 41623, f.3: 58
Add. ms 41623, f.12v: 89

Add. ms 41623, f.16: 61
Add. ms 41623, f.17: 114
Add. ms 41623, f.22: 103
Add. ms 41623, f.38v: 96
Add. ms 41623, f.42v: 76
Add. ms 41623, f.47: 98
Add. ms 41623, f.48v: 84
Add. ms 41623, f.97v: 34
Add. ms 41623, f.100: 59

Add. ms 54782, f.49: 94
Add. ms 41623, f.64v: 46
Add. ms 54782, f.65: 44
Add. ms 41623, f.66v: 74
Add. ms 54782, f.73v: 10
Add. ms 54782, f.226: 107
Add. ms 54782, f.265v: 74

Egerton ms 747, f.8: 115
Egerton ms 747, f.12: 23
Egerton ms 747, f.12: 112
Egerton ms 747, f.14: 25
Egerton ms 747, f.14v: 18
Egerton ms 747, f.16: 25
Egerton ms 747, f.16: 117
Egerton ms 747, f.16v: 31
Egerton ms 747, f.25v: 50
Egerton ms 747, f.28: 84
Egerton ms 747, f.30: 79
Egerton ms 747, f.30v: 28

Egerton ms 747, f.34v: 49

Egerton ms 747, f.37: 69
Egerton ms 747, f.40v: 68

Egerton ms 747, f.41: 24
Egerton ms 747, f.41: 86
Egerton ms 747, f.43v: 42
Egerton ms 747, f.48: 64
Egerton ms 747, f.50v: 54
Egerton ms 747, f.55v: 62
Egerton ms 747, f.56: 73
Egerton ms 747, f.68v: 85
Egerton ms 747, f.64v: 23
Egerton ms 747, f.64v: 26
Egerton ms 747, f.70: 65
Egerton ms 747, f.72: 93
Egerton ms 747, f.72v: 92
Egerton ms 747, f.73: 100
Egerton ms 747, f.78v: 38
Egerton ms 747, f.81: 88
Egerton ms 747, f.85v: 105
Egerton ms 747, f.88: 95
Egerton ms 747, f.88v: 63
Egerton ms 747, f.89: 43
Egerton ms 747, f.89v: 72
Egerton ms 747, f.93: 108
Egerton ms 747, f.93: 110
Egerton ms 747, f.93v: 22
Egerton ms 747, f.98: 70
Egerton ms 747, f.101: 50
Egerton ms 747, f.101v: 83
Egerton ms 747, f.102v: 38
Egerton ms 747, f.108v: 32
Egerton ms 747, f.108: 116

Egerton ms 747, f.208: 71

Egerton ms 2020, f.12v: 21
Egerton ms 2020, f.26v: 48
Egerton ms 2020, f.28: 119
Egerton ms 2020, f.33: 41
Egerton ms 2020, f.56v: 24
Egerton ms 2020, f.60: 81
Egerton ms 2020, f.94: 2, 120
Egerton ms 2020, f.163: 55
Egerton ms 2020, f.165: 55

Harley ms 4425: f.12v: 13
Harley ms 1585: f.33v: 9
Harley ms 4425: f.51v: 77
Harley ms 1585: f.52: 73
Harley ms 1585: f.54v: 48
Harley ms 4425: f.57: 78

Royal ms 14 E. VI, f.157: 14

General Index